ROBERT GROGAN

July 2014

Kalahari Summer
In photographs and oils

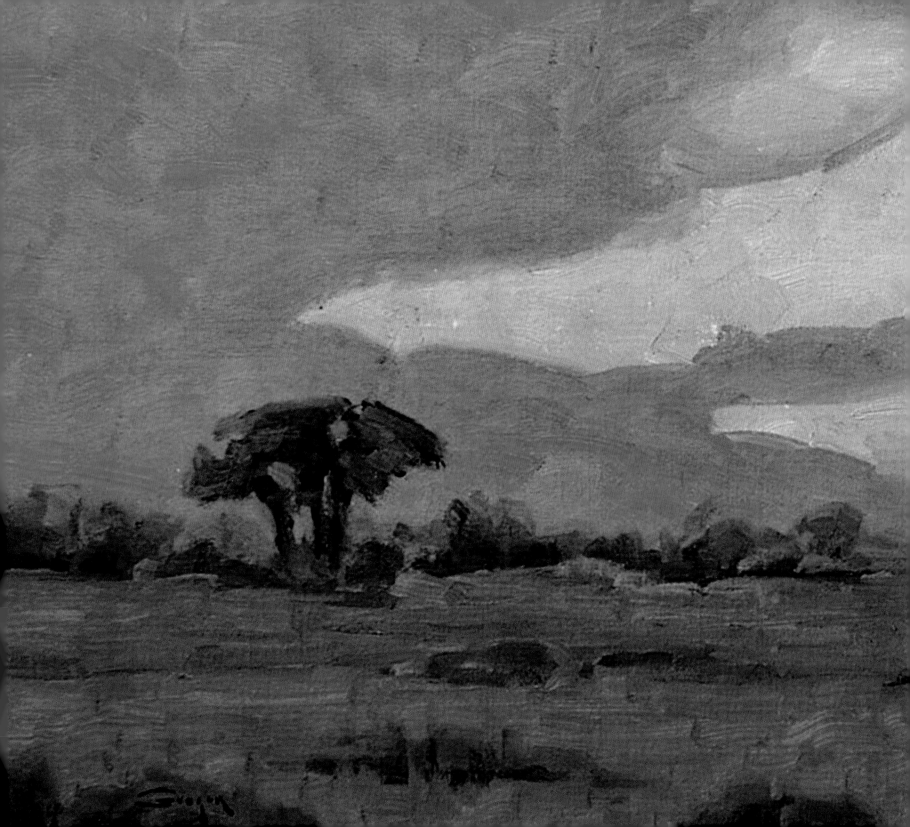

Kalahari Summer

In photographs and oils

Robert Grogan

Acknowledgements

MY SINCERE THANKS go to the entire SANParks staff at the Kgalagadi Transfrontier Park. The overall operation of a large park in a remote location presents quite a challenge, and I have always been impressed by the dedication and competence of the staff at KTP.

Thanks to Jane Lavino, Sugden Family Curator of Education and Exhibitions at the National Museum of Wildlife Art in Jackson, Wyoming, for her kind remarks in the foreword and whose positive reaction to my Kalahari Summer idea at the concept stage was very helpful.

For Graeme Arnott, one of South Africa's premier bird artists, and a good friend, thank you for looking over my images and text on all things avian.

Dr Gus Mills, retired research scientist from SANParks, was kind enough to review my text. Dr Mills is a repository of knowledge about the Kalahari, and I sincerely thank him for contributing his expertise.

Lastly many thanks to Pippa Parker, Commissioning Editor at Struik Nature, for her enthusiastic encouragement, and to all the Struik staff whose efforts made Kalahari Summer a reality.

PREVIOUS SPREAD Kalahari Evening Sky, oil on canvas, 22" x 28"

RIGHT A mature male lion prowls through lush summer grass.

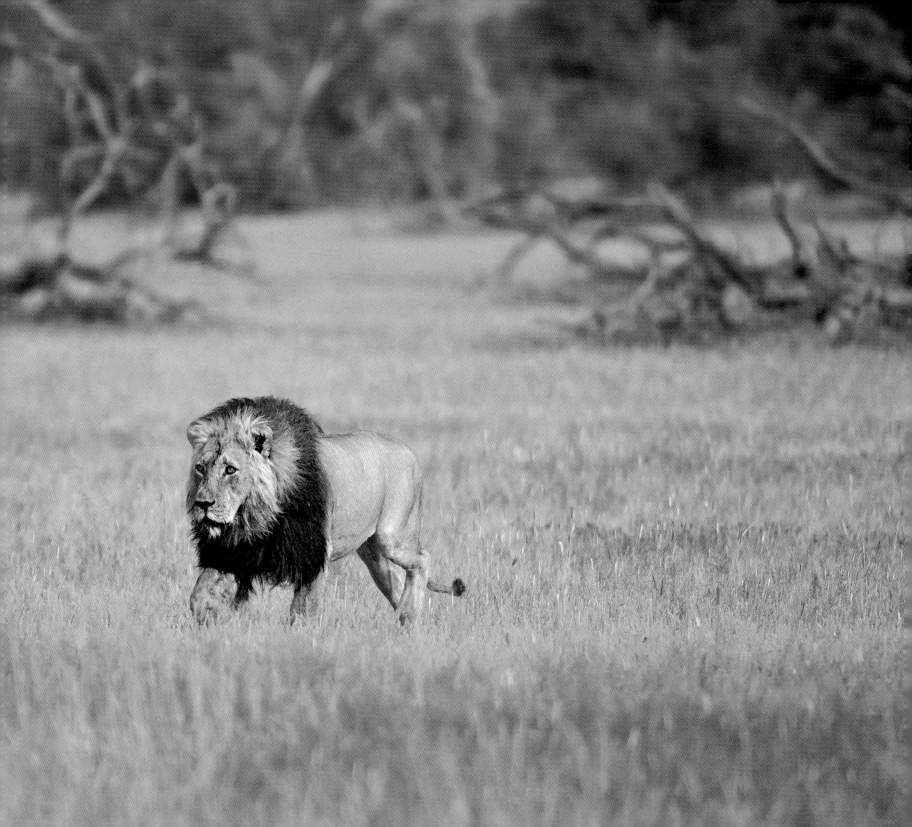

Foreword

ONE OF THE PERKS OF WORKING AT AN ART MUSEUM is the opportunity to meet artists and befriend them. I had the good fortune to meet artist Robert Grogan eight years ago through the National Museum of Wildlife Art in Jackson, Wyoming. Grogan's striking paintings are regularly featured in our prestigious Western Visions Show & Sale. I love his landscapes for their expressive economy of brushwork, brilliant use of colour and the way they evoke the essence of place. In 2006 we invited Grogan to spend a month at the Museum as artist-in-residence. During this time we discovered his talents as a teacher and his ability to demystify art-making for grateful visitors. We learned that Robert doesn't do anything halfway. He enjoys challenges, hard work and painstaking pursuits. He pushes the limits of his potential in different arenas. For this reason, I wasn't completely surprised to discover that Robert is also an excellent photographer. What did surprise me was the quantity of truly exceptional photographic images he has amassed.

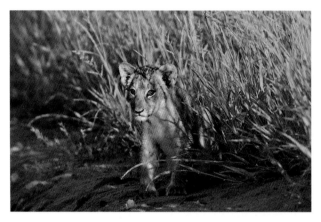

Robert Grogan has lived in some of the most beautiful places in the world. Most of his life has been spent in Alaska. In addition to his career with the State of Alaska working on natural resource matters, he has also spent a great deal of time in Alaska's wild places. Robert and his wife Lee first travelled to Africa's Kalahari region in 1974. More recently the two have divided their time between Sun Valley, Idaho and Franschhoek, South Africa. Robert and Lee are experts at self-sufficiency and can comfortably stay in the back country for six weeks at a time. This gives them exceptional access to remote areas. Residing in one location, without interruption, also facilitates an enviable ease with one's subjects.

Kalahari Summer is unique in its cohesive artistic vision. Robert Grogan's paintings and photographs together describe an incredible place. This book is successful, in large part, because of the unique perspective and personality of the artist himself. Robert's lifelong love of wild places and wild things makes him a charismatic guide to the Kalahari. He immerses himself in challenging landscapes and generously shares what is magnificent and elusive. He has the ability to be at the right place at the right time. Through his artistic eye we get to experience the full moon at daybreak, towering cloudscapes, the twitch of a leopard's tail, and the glint in a raptor's gaze.

Morning at Achterlonie, oil on canvas, 6" x 8"

6

Robert Grogan's oil paintings and digital photographs both captivate viewers. They speak of his particular strengths as an artist: strong composition, a mastery of light, and the ability to create vibrant colour harmonies. The paintings and photographs work seamlessly side by side. In the museum world, we are accustomed to seeing these two media relegated to different galleries for exhibition. Like the oil and water traditionally used in making paintings and developing photos, they don't often mix in mutually supportive ways. Robert paints landscapes and photographs wildlife, and there is a coherent logic in this approach. Painting is something he is drawn to when he feels urgently that he 'must paint.' 'When you paint,' he says, 'you interact with what you see, and you control a lot to communicate a visceral feel.' You can, for example, move a tree or eliminate a power line in order to get what you are after while still being true to the place. You also learn to hedge your bets on things you can't control. 'You learn to be a bit of a weatherman and paint in such things as the rapidly shifting clouds first.'

Robert describes the act of photographing in different terms. 'It is something I do that gives me an excuse to be out and learn about wildlife.' When photographing wildlife 'you don't control any of it!' There are so many variables. Success comes, over time, from repeated failure and patiently learning from mistakes. He explains that you eventually learn to wait or to move almost intuitively. You learn to study a prey animal's demeanour and to make educated guesses about what will transpire. Robert's paintings and photographs give insight and understanding beyond documentation.

As Robert says, there are many reasons not to travel in the Kalahari during the summer wet season. The challenges are immense, but clearly, the payoff for someone who is a master of colour and light is rich. With Robert as a guide, we gain access to a very special place. *Kalahari Summer* is a visual celebration and a masterful accomplishment.

JANE LAVINO
Sudgen Family Curator of Education and Exhibitions
National Museum of Wildlife Art, Jackson, Wyoming

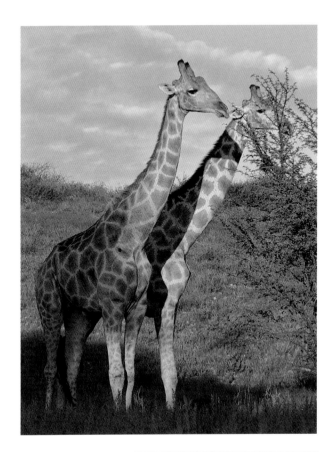

Introduction

THE KALAHARI DESERT is arid savanna, rather than true desert, though its name, which means 'thirsty land', suggests otherwise. It encompasses most of Botswana and parts of South Africa and Namibia, an area of some 900 000 square kilometres. Much of the time, this landscape consists of dry grassland and red sands. Only those animals that can tolerate periods of drought manage to survive here year-round. Rain is sporadic and unpredictable, falling during the summer months. However, after a period of good rains, many species that require daily water move into the region briefly to take full advantage of the temporary lush grazing, disappearing again at the onset of the next dry period.

Winter is the most popular time for visiting the Kalahari: it provides the best game viewing, since vegetation is at a minimum, and it is also

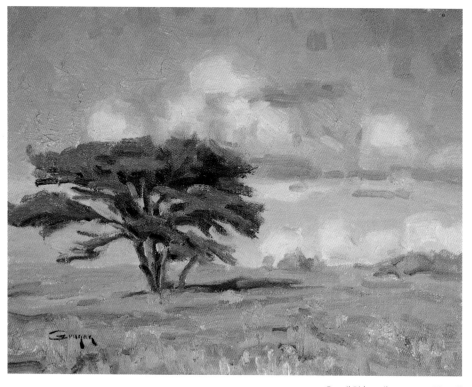

Cattail Ridge, oil on canvas, 8" x 10"

quite comfortable, as the days are warm and clear and the nights are cold. By contrast, there are many reasons not to travel in the Kalahari during the hot, wet, summer season. The area is prone to flash floods, and roads often become impassable. Enormous violent thunderstorms occur with little warning. Daily temperatures reach highs of over 40 degrees Celsius, while cloud cover frequently inhibits radiative cooling at night. During these humid evening hours, snakes like puff adders and Cape cobras are active and widespread. Scorpions are also more active at night, particularly in windy weather. Flying insects can be a nuisance, and the tall grass is a drawback when trying to spot wildlife.

From an artist's perspective, however, the positives of the Kalahari summer far outweigh these negatives. The landscape – seldom dramatic in its own right – is transformed by a daily build-up of colossal banks of cloud. After rain, the land itself may undergo a metamorphosis as red dunes become rolling green hills, and profusions of wildflowers provide splashes of vibrant colour. These summer effects are short-lived and spotty. Summer may arrive in one area, transforming it into a meadow of grass and blossom, while the terrain just a short distance away remains entirely untouched. Sometimes the summer rains fail altogether or arrive very late in the season, so it is always worth checking with park officials before travelling to the region if you hope to experience a lush summer show. Every day is different, and visitors need to be prepared for dealing with the many irritants that accompany travel in this season. Above all, they should be adaptable.

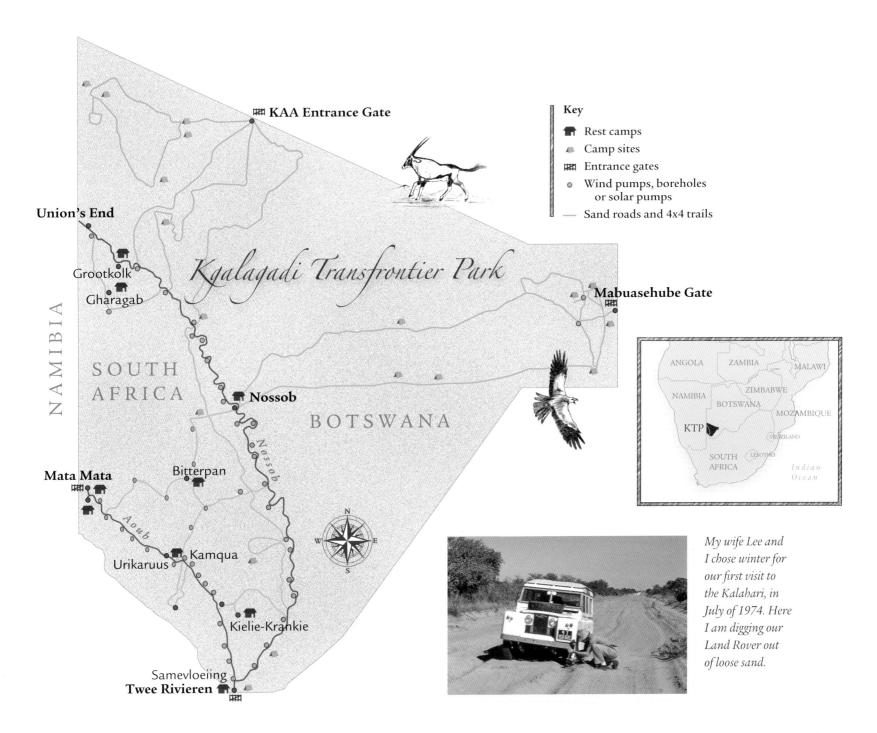

Key

🏠 Rest camps
⛺ Camp sites
▦ Entrance gates
● Wind pumps, boreholes
 or solar pumps
— Sand roads and 4x4 trails

▦ **KAA Entrance Gate**

Kgalagadi Transfrontier Park

Union's End

Grootkolk

Gharagab

Mabuasehube Gate

NAMIBIA

SOUTH
AFRICA

Nossob

BOTSWANA

Mata Mata

Bitterpan

Kamqua

Urikaruus

Kielie-Krankie

Samevloeiing
Twee Rivieren

Aoub

Nossob

ANGOLA | ZAMBIA | MALAWI
NAMIBIA | ZIMBABWE
BOTSWANA | MOZAMBIQUE
KTP | SWAZILAND
SOUTH | LESOTHO
AFRICA | *Indian Ocean*

My wife Lee and I chose winter for our first visit to the Kalahari, in July of 1974. Here I am digging our Land Rover out of loose sand.

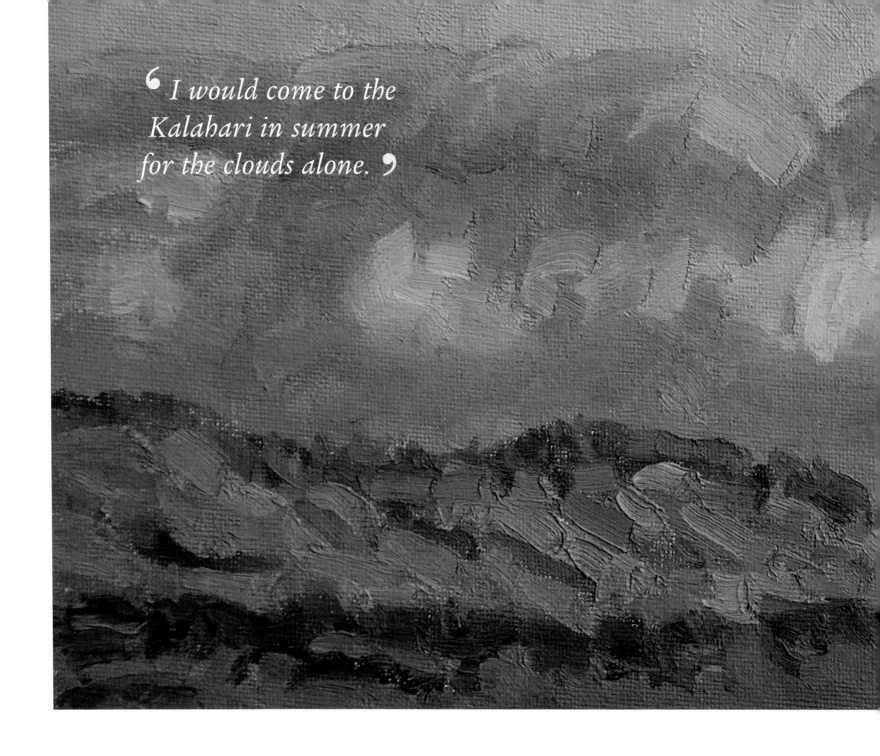

'I would come to the Kalahari in summer for the clouds alone.'

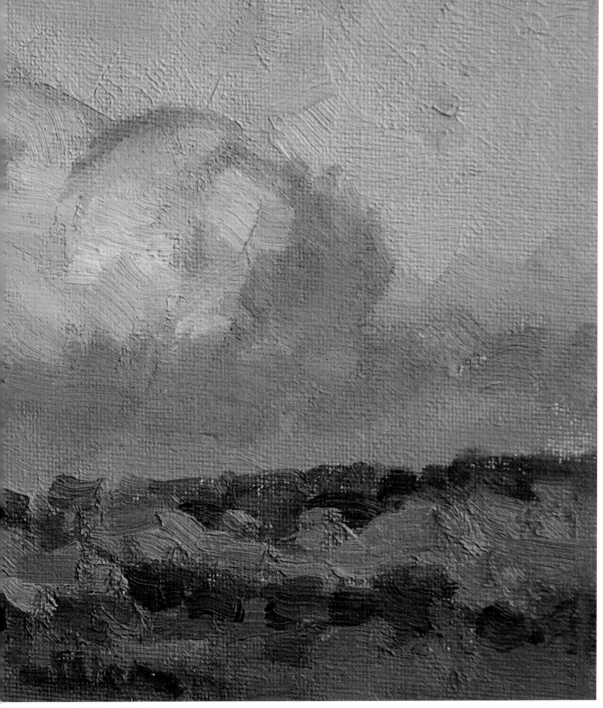

Dune with Evening Clouds, oil on canvas, 6" x 12"

There is little point in making inflexible plans – a 'pitch up and wait' approach works best. The Kalahari, more than most other destinations, seems to demand that visitors stay as long as possible. Often, we have found that the difference between a successful trip and a failed one lay in having enough time to wait for a special sighting or for just the right cloud formations for a painting.

Visitors to the Kgalagadi Transfrontier Park in South Africa and Botswana often focus exclusively on spotting big cats. This is a great pity, given the inordinate beauty that rewards a patient visitor with a keen eye. For me, the most magical part of summer in the Kalahari has always been the merging of sky and ground as massive storm clouds form overhead. Once, while visiting a neighbour at the Nossob Rest Camp in the Kgalagadi Transfrontier Park, I happened to mention my long preoccupation with the Kalahari's magnificent summer clouds, telling him that I would come for the clouds alone. Later he confessed that he had spent his entire life in the area and had travelled extensively in the Kalahari during summer but had never paid much attention to the clouds. He joked that I had 'ruined it' for him as he was now mesmerized by the spectacle in the sky to the exclusion of almost everything else!

Over many summers in the Kalahari, a clear pattern has emerged in my activities: I paint landscapes and I photograph wildlife. Advances in digital technology, including post-capture processing, have brought photography and painting closer than ever before. Of course, in both cases one seeks a solid composition and interesting light, but I tend to think about these activities quite differently. Photography has helped me to develop the patience needed to observe wildlife meaningfully and to learn about animals' habits and behaviour. However, I want my landscape paintings to convey something more to the viewer. It may be the shimmering heat, the drama of a stormy sky or the incredible desolation of the place, but unless I can capture the essence of a moment I feel there is little need for a painting.

Whether I intend to complete the entire painting in the open air (*en plein air*) or to finish off in the studio, I always begin with a small thumbnail drawing of my subject, applying the classical rules of composition such as not placing the subject centrally, not dividing the painting in a predictable way, and avoiding pairs of objects. I also identify each part of the drawing as either light or shadow, so that the thumbnail can later serve as a light and shadow map. Unless the thumbnail drawing shows real promise at this stage, I don't take the idea any further. Although it is tempting to race forward, I've learned that satisfying composition and lighting are essential if the drawing is to lead to a pleasing painting. Given

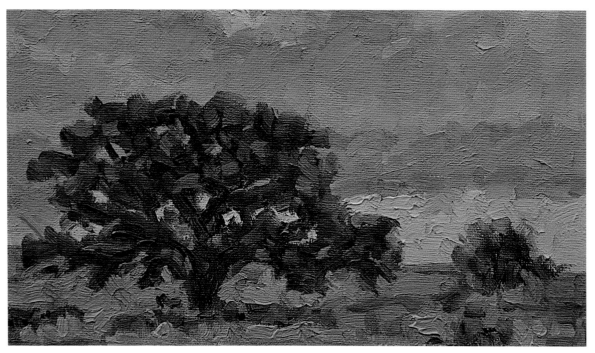

Sunset near Grootkolk, oil on canvas, 8" x 10"

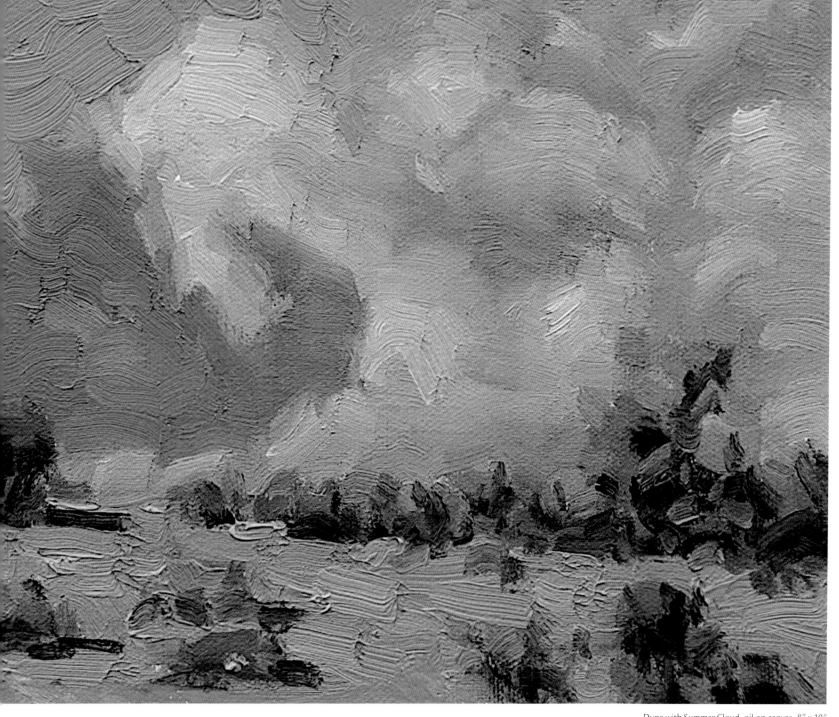

Dune with Summer Cloud, oil on canvas, 8" x 10"

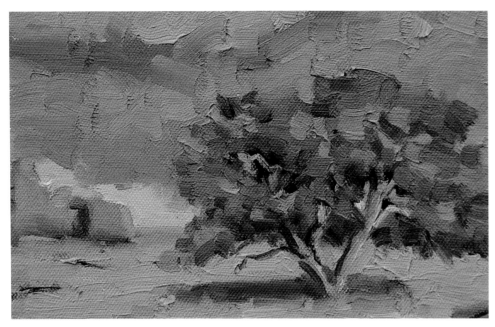

Wall of Water, oil on canvas, 6" x 8"

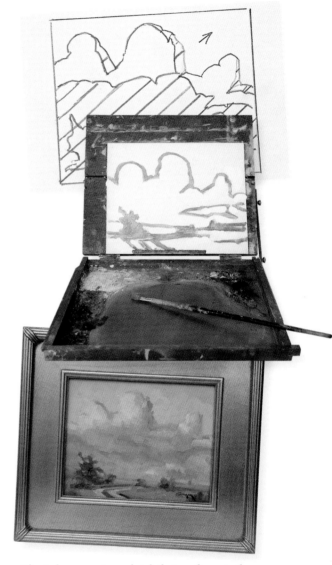

I begin by preparing a sketch that conforms to the rules of good composition and that plots out the areas of light and shadow. I then transfer the detail from the thumbnail to a canvas panel. If the results are pleasing, I may take photographs to use as references for a studio painting, or I may simply paint en plein air.

that so many of my Kalahari paintings are cloudscapes and that storm clouds are highly transient, the thumbnail has to serve as a rigid plan. Hurrying to keep up with the endlessly changing cloud formations is a recipe for frustration. Once I have a satisfactory thumbnail, I use a thin transparent wash to transfer the outline onto a canvas panel. I then check that the panel matches the thumbnail drawing. I usually also take a few photographs of the scene for later reference should I decide that a sketch in the field warrants a larger studio painting.

Generally I use thin paint for shadow portions, reserving thicker paint for the light and highlight areas. The shadow passages hold the drawing, while the light areas carry the colour. I use titanium white and mix my colours from just three primaries – cadmium yellow light, alizarin crimson and ultramarine blue. I see great beauty in nature's colours and strive for rich but literal shades.

For the reader already familiar with a Kalahari summer, I hope these images will evoke the heat, the rumbling of distant thunder, and the wonderful fragrance of an approaching storm. And for readers who have not yet experienced a summer season in the Kalahari, may my images transport you to this harsh land during its brief season of splendour.

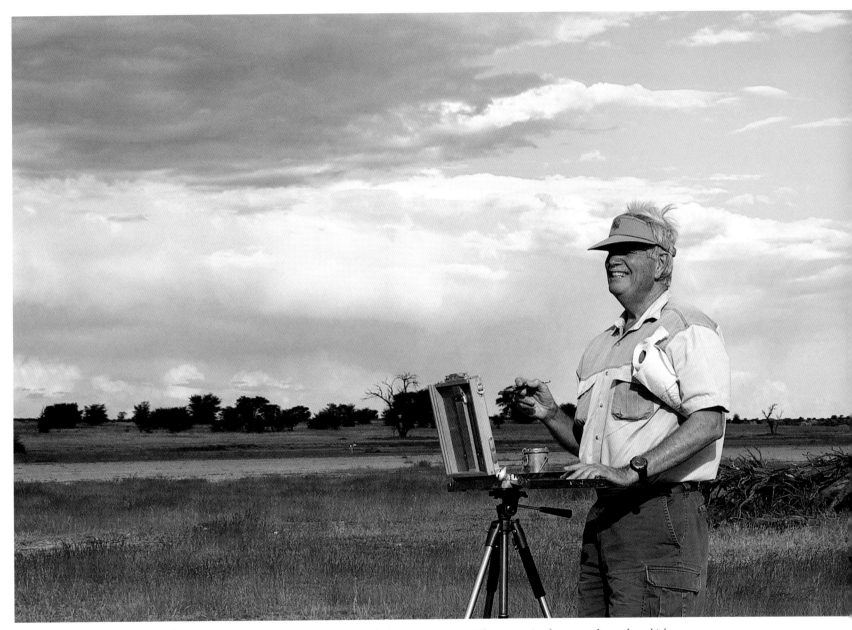

I consider painting in the Kalahari summer season to be an extreme form of plein air *painting. Where permitted, one can leave the vehicle and paint. However, given the abundance of predators, I don't attempt this unless I have someone to keep watch for approaching danger.*

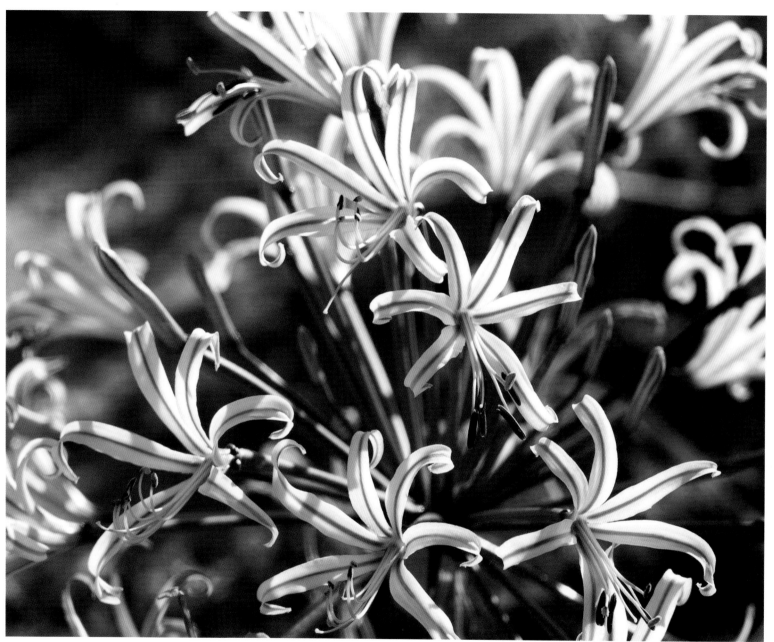

Vlei lily

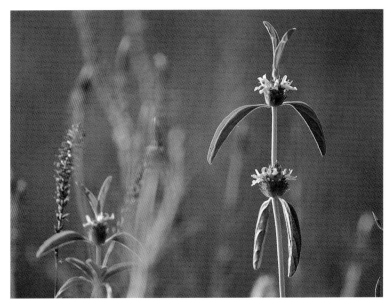

Tumbleweed

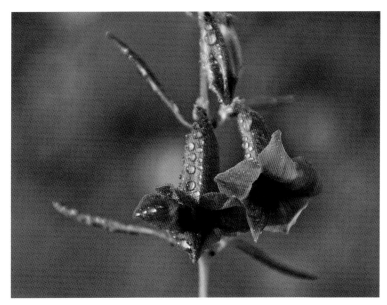

Thunderbolt

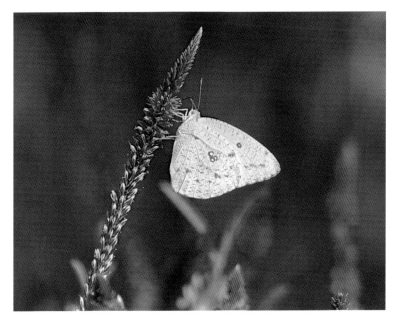

Female African migrant butterfly on cat's tail

After summer rains, carpets of wildflowers grace the red Kalahari sands, providing attractive and obliging photographic subjects. Among my favourites are the vlei lily (a perennial bulb), the tumbleweed with its spherical clusters of white blossom, and the sight of early morning dew on a thunderbolt blossom.

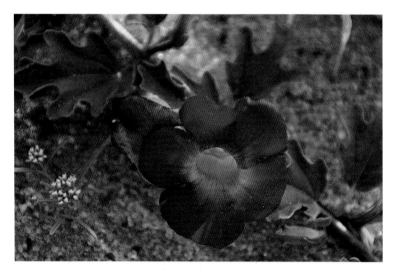

Devil's claw

Devil's thorn

Ouheip

Springbokopslang

The summer season brings a myriad colourful wildflowers. When I photograph flowers, I look both for strong compositions and complementary colour combinations.

18

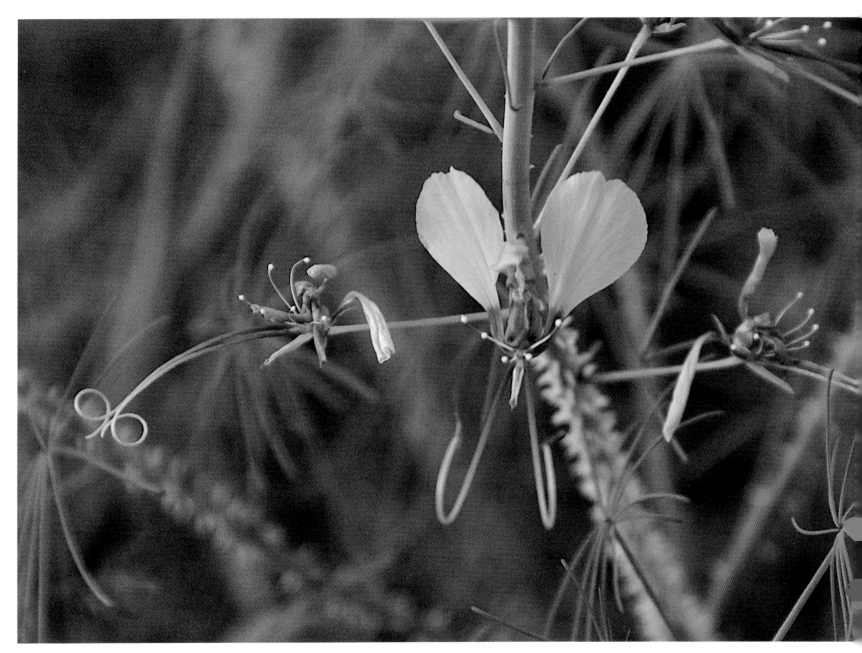

Yellow mouse-whiskers

19

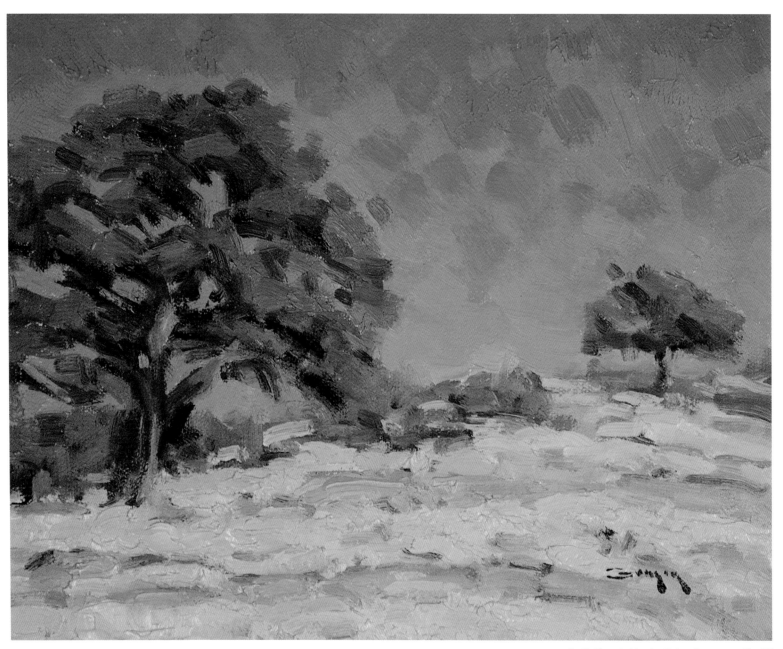

Devil's Thorn in Morning Light, oil on canvas, 8" x 10"

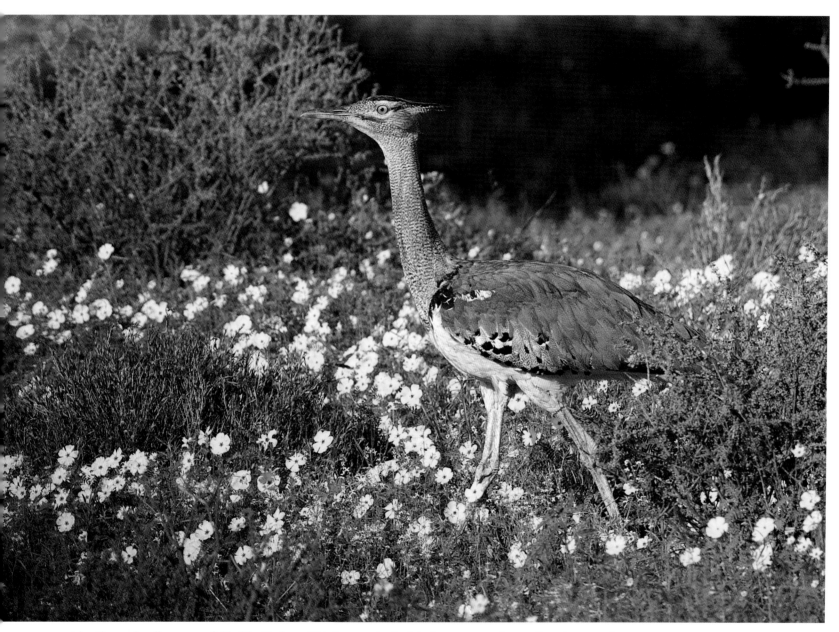

A kori bustard walks across a field of devil's thorn. This fast-growing herb is always among the very first plants to take advantage of good rains. It sends out long trailing shoots and quickly transforms the sand into a sea of bright yellow flowers.

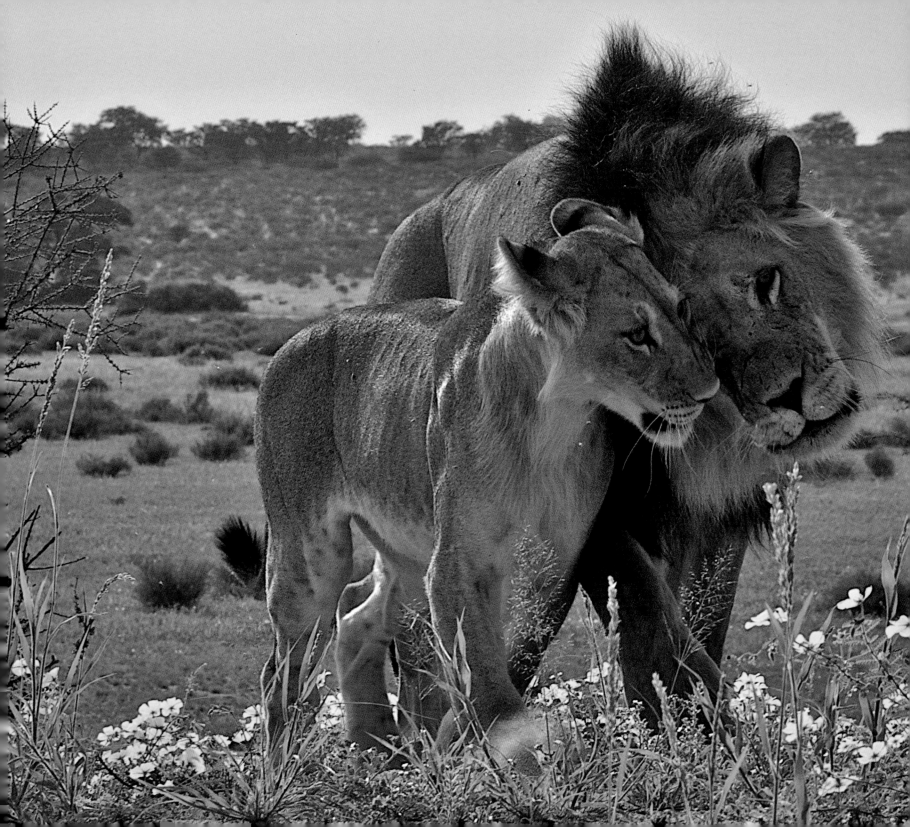

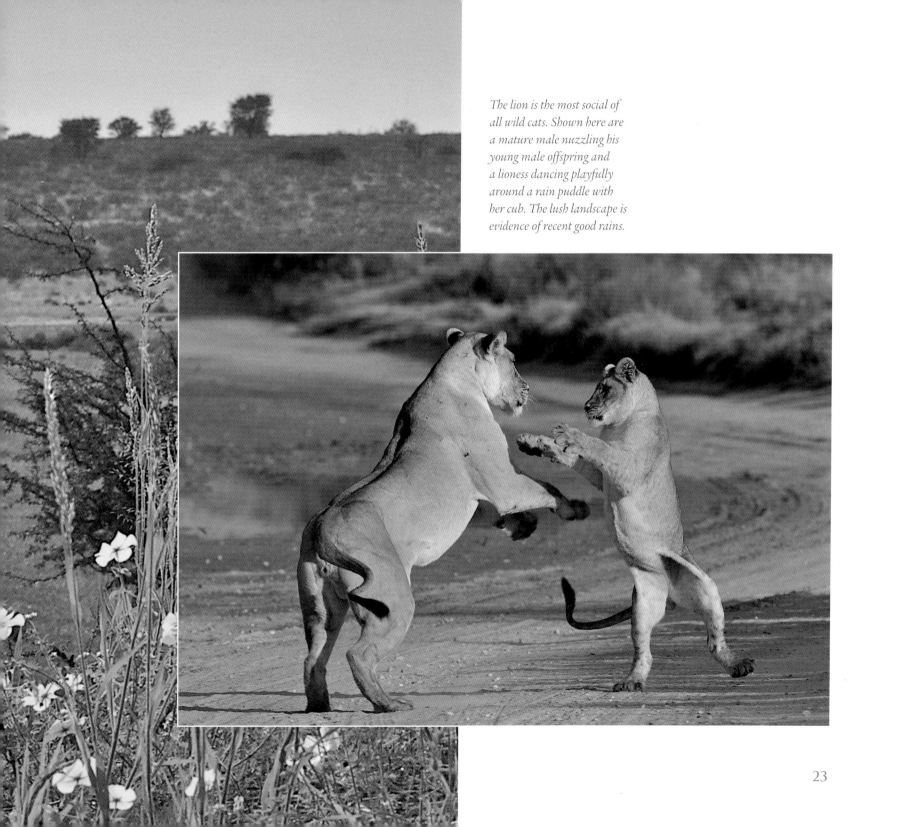

The lion is the most social of all wild cats. Shown here are a mature male nuzzling his young male offspring and a lioness dancing playfully around a rain puddle with her cub. The lush landscape is evidence of recent good rains.

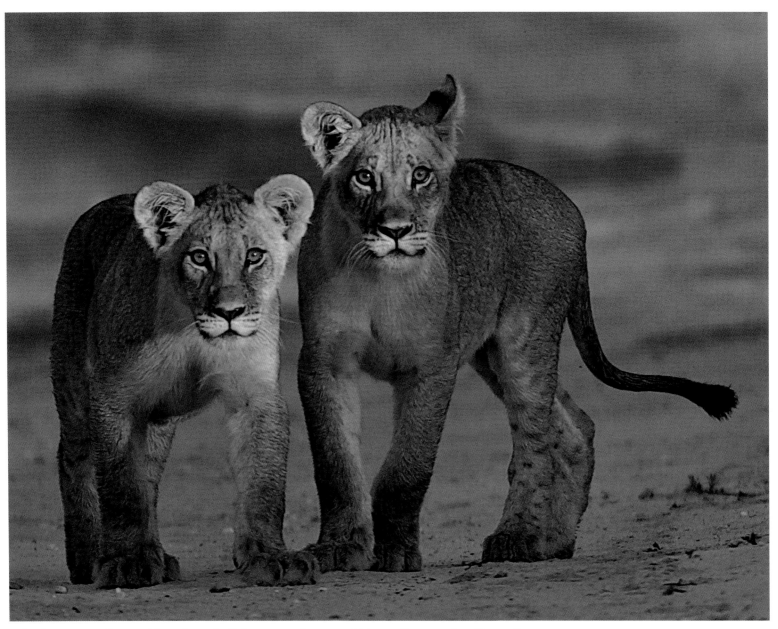

When I encounter a lioness with a cub or cubs, I always try to keep my vehicle at a distance and avoid crowding the family. If the mother remains calm, the curious cubs will often approach me of their own accord.

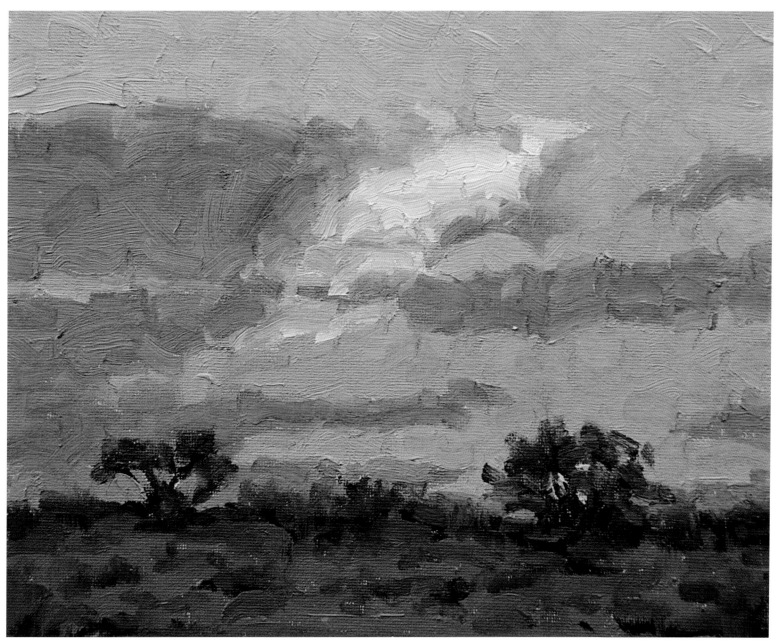

Kalahari Clouds, oil on canvas, 8" x 10"

Male garden acraea

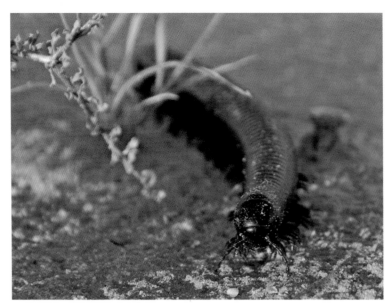

Giant African black millipede

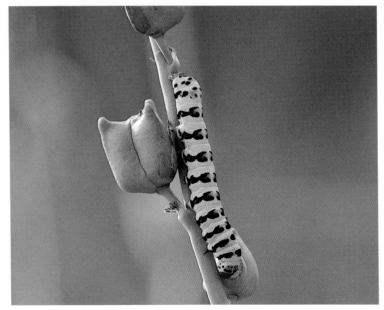

Cherry spot moth caterpillar

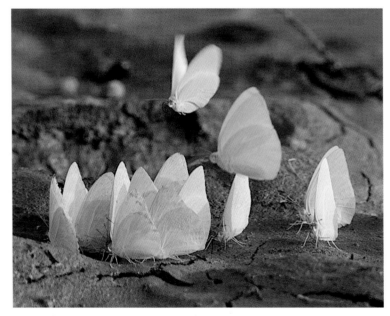

Male African migrant butterflies

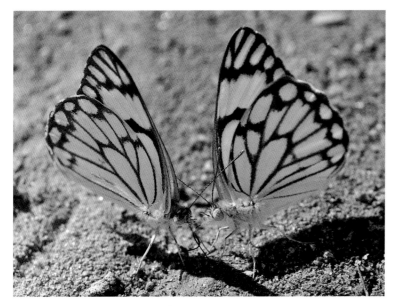

Male brown-veined white butterflies

Though I enjoy photographing the iconic big cats and raptors of the Kalahari, it's often the smallest creatures, like insects and birds, that best convey the ethereal atmosphere of a summer's evening. Butterflies, like brown-veined whites, may be present in large numbers at this time of year. I've often found that if I am patient, these and other insects provide me with the sort of compositions and colour combinations that make for the most rewarding photography.

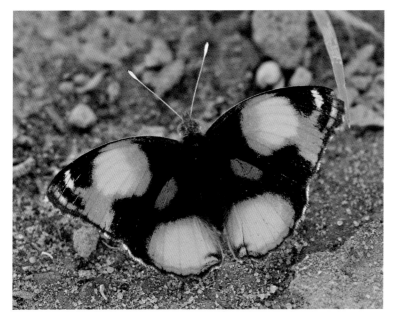

Yellow pansy butterfly

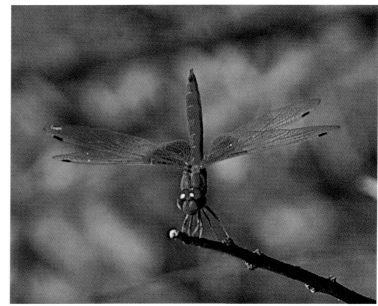

Kirby's dropwing dragonfly

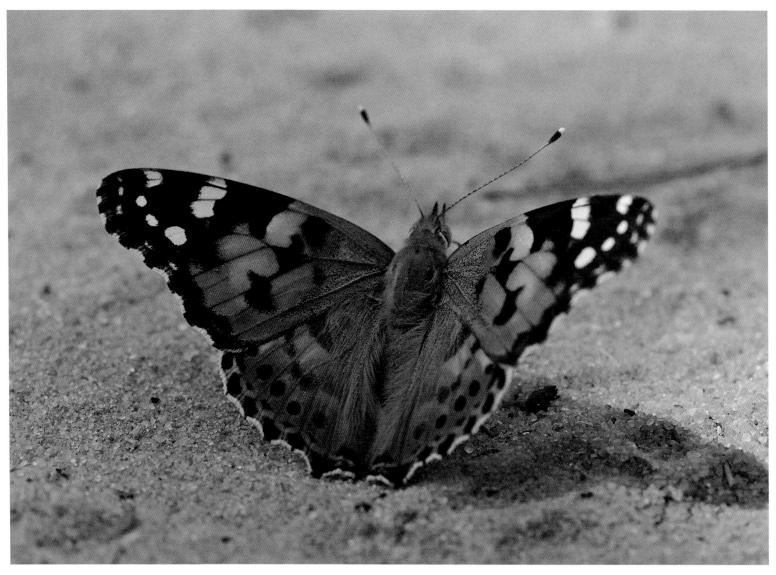

Although mosquitoes and other biting insects can be a nuisance in the wet summer months, visitors with no particular interest in entomology will still appreciate the exquisite forms and colours of many of the region's insects. Shown here are two widespread butterfly species. The butterfly above is a painted lady, while that featured opposite is an African monarch that has settled on a cat's tail bloom.

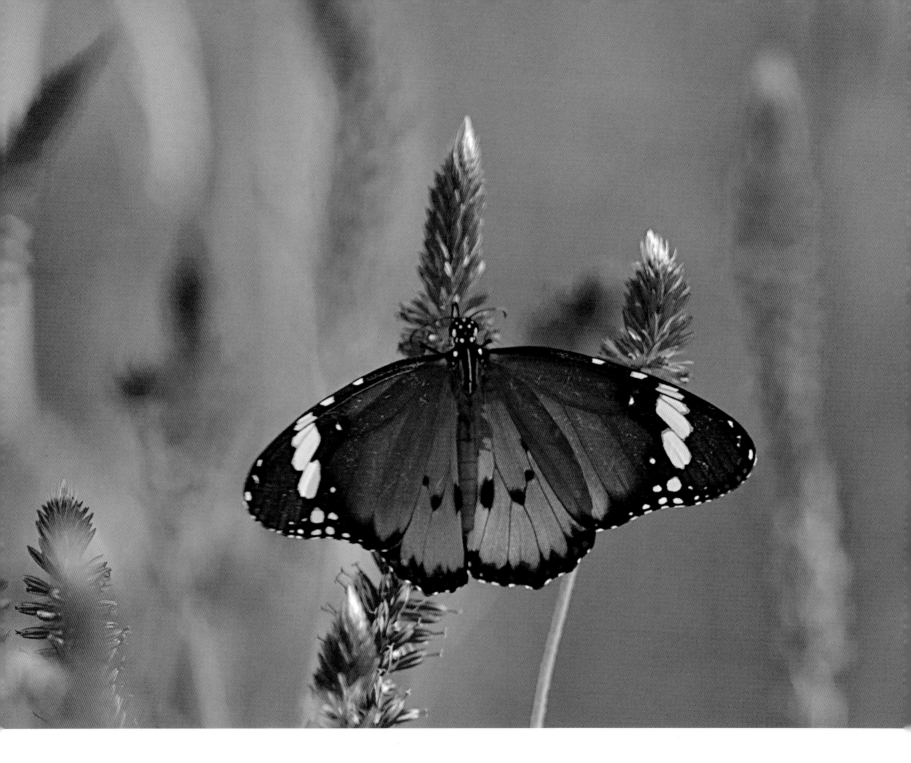

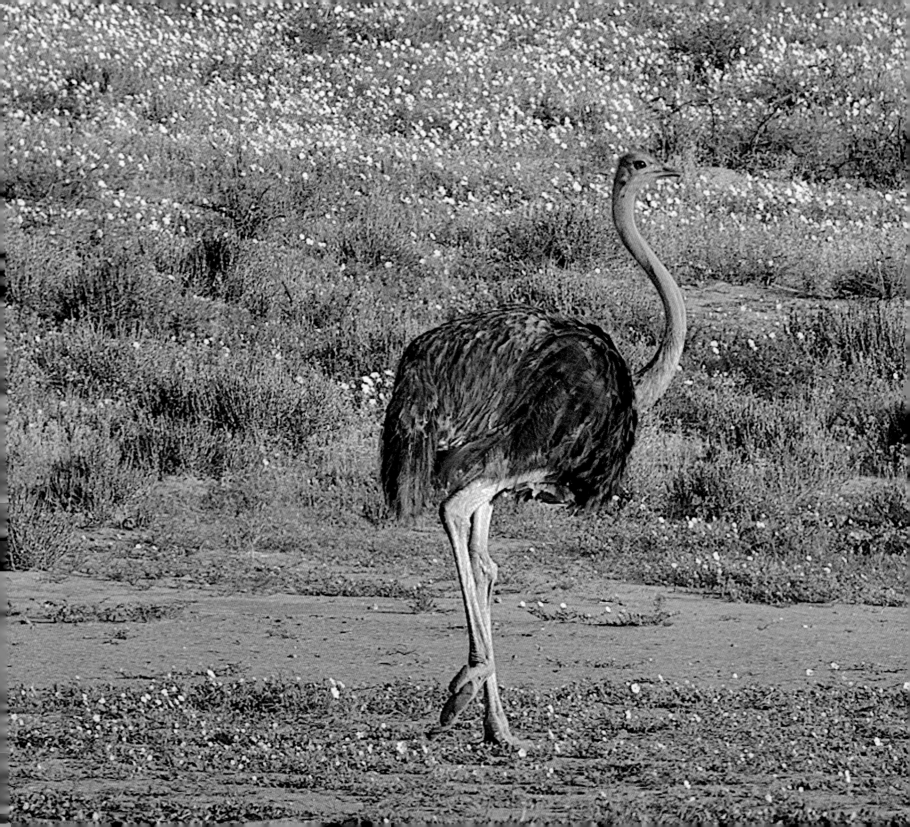

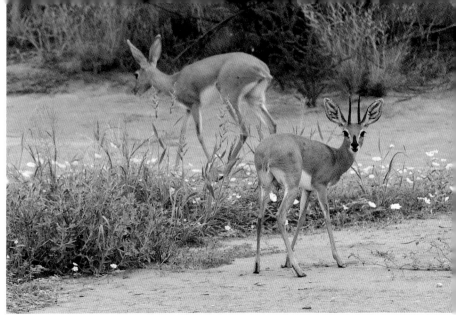

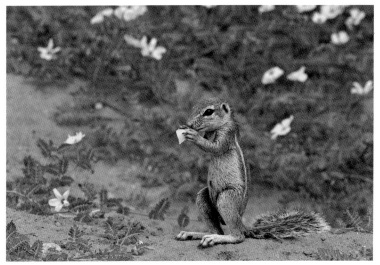

The devil's thorn has spiky fruits that stick to hooves and claws, which aids seed dispersal. This plant also provides food for a number of species, like the southern African ground squirrel – here seen feeding on one of the yellow blossoms – and the steenbok. This buck is well suited to life in such a thirsty environment, as its diet provides it with all the water it needs. Shown to the left is a female ostrich in a field of devil's thorn. The bird walked slowly on a parallel course with my vehicle for quite some distance, backdropped by the flowers, giving me plenty of time to photograph her.

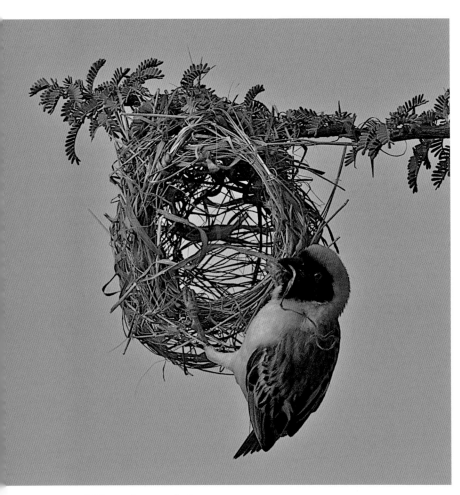

Male southern masked weaver

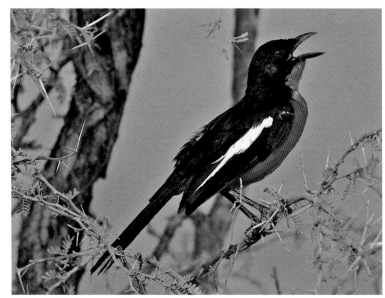

Crimson-breasted shrike

Female southern masked weaver

The Kalahari is justly renowned for its raptors, but there are many other birds worth looking out for, too, from the industrious weavers to showstoppers like crimson-breasted shrikes, swallow-tailed bee-eaters and lilac-breasted rollers.

Ashy tit

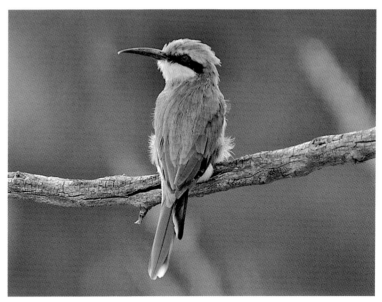

Swallow-tailed bee-eater

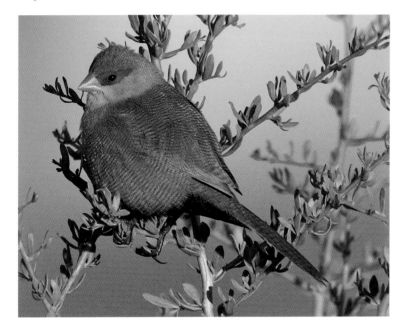

Common waxbill

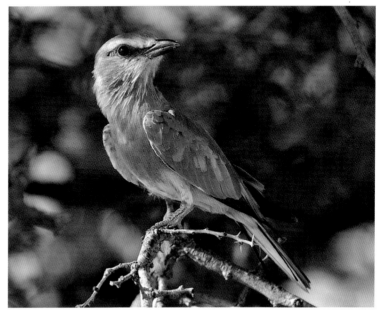

Lilac-breasted roller

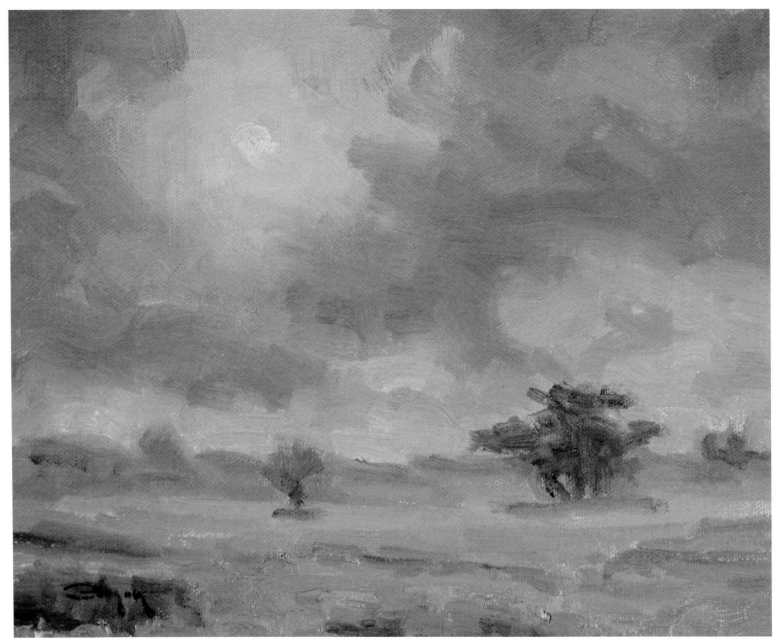

Dawn in the Dunes, oil on canvas, 8" x 10"

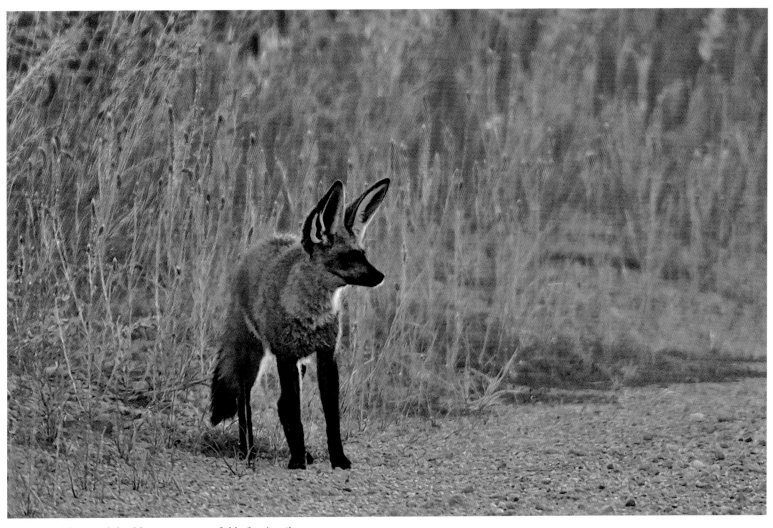

A bat-eared fox stands backlit at sunset in a field of cat's tail.

OVERLEAF *Despite the darkening sky, these blue wildebeest seem completely oblivious to the approaching thunderstorm.*

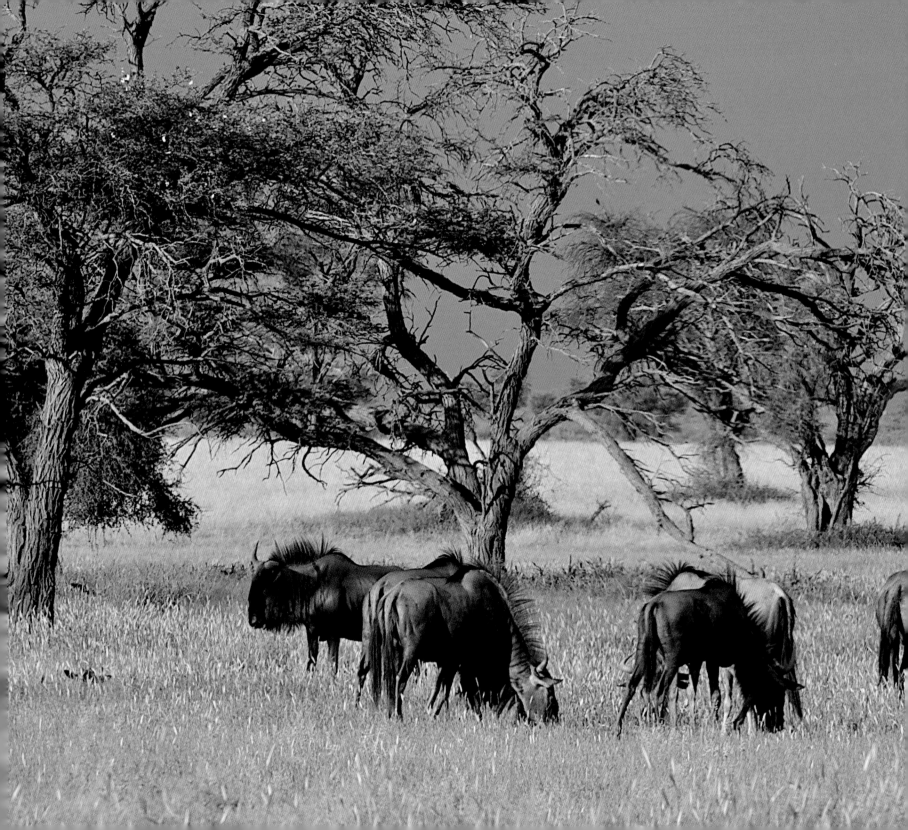

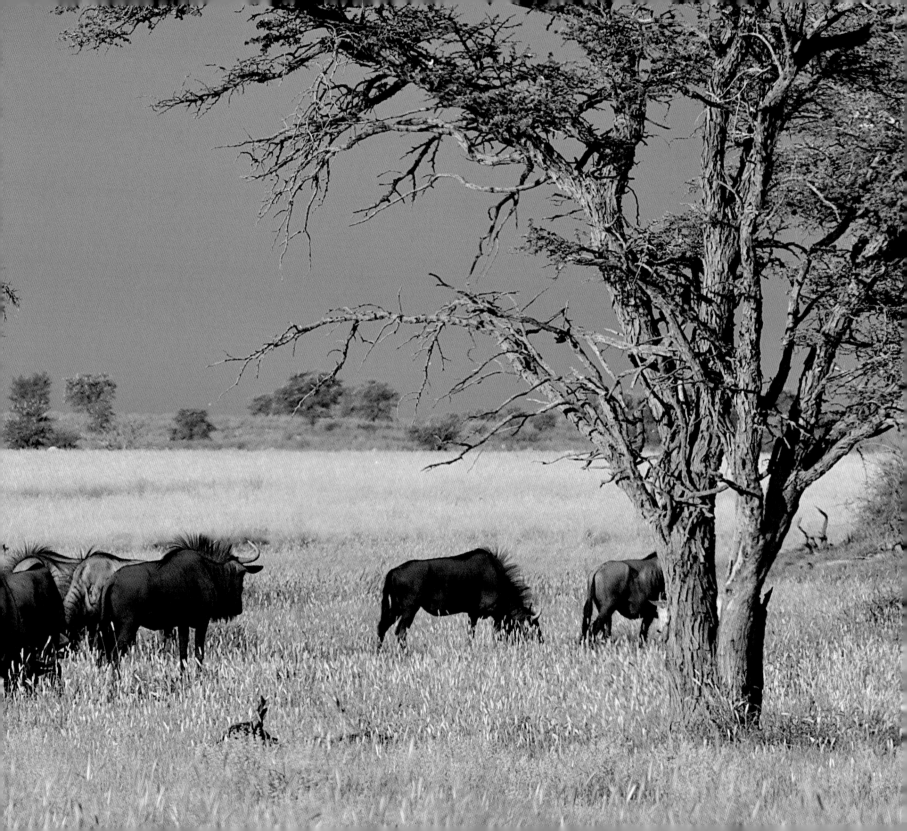

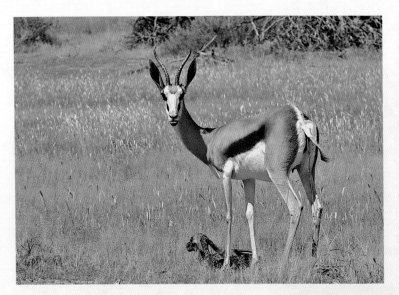

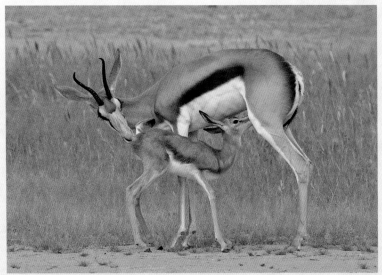

Springbok lambing

Springbok, the only gazelle found south of the Zambezi River, have evolved to drop their lambs at roughly the same time. The lambs are able to walk shortly after birth but remain exceedingly vulnerable. This is a time of plenty for cats, raptors and other predators; it's also a prime opportunity for teaching youngsters how to hunt. So many lambs are taken during this period that it's a wonder any survive. The newborn springbok lamb shown opposite was up and walking within eleven minutes of its birth. The cautious mother then nudged her lamb into the cover of some bushes before allowing it to suckle.

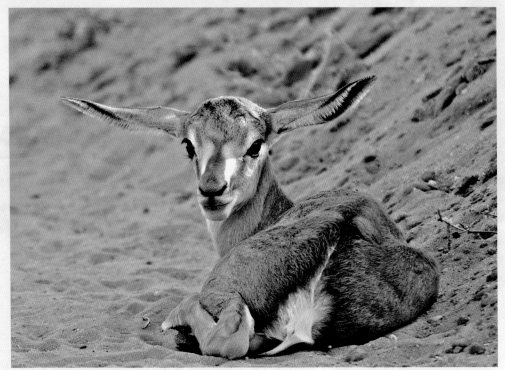

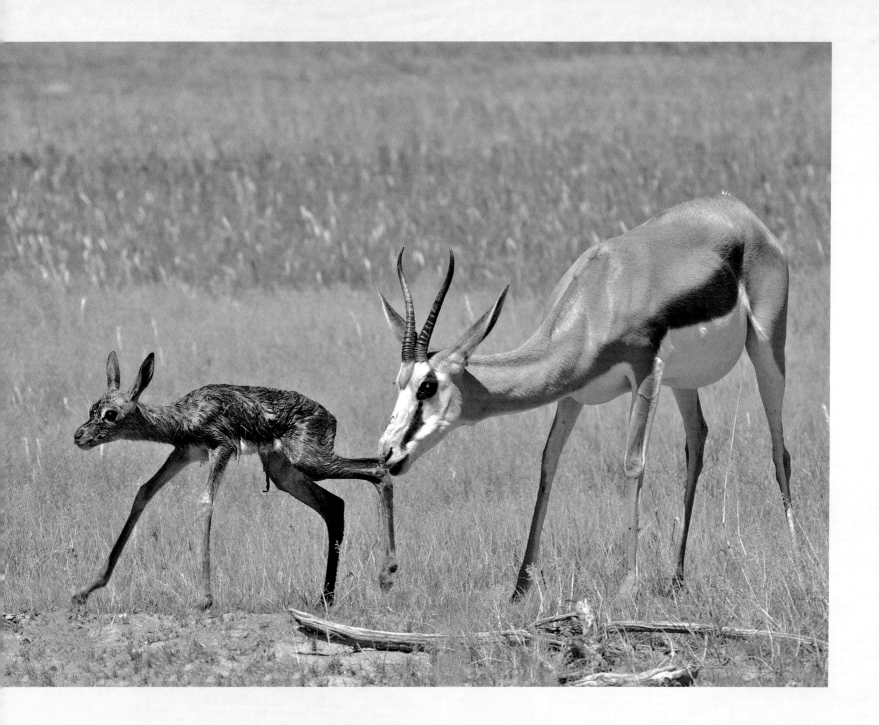

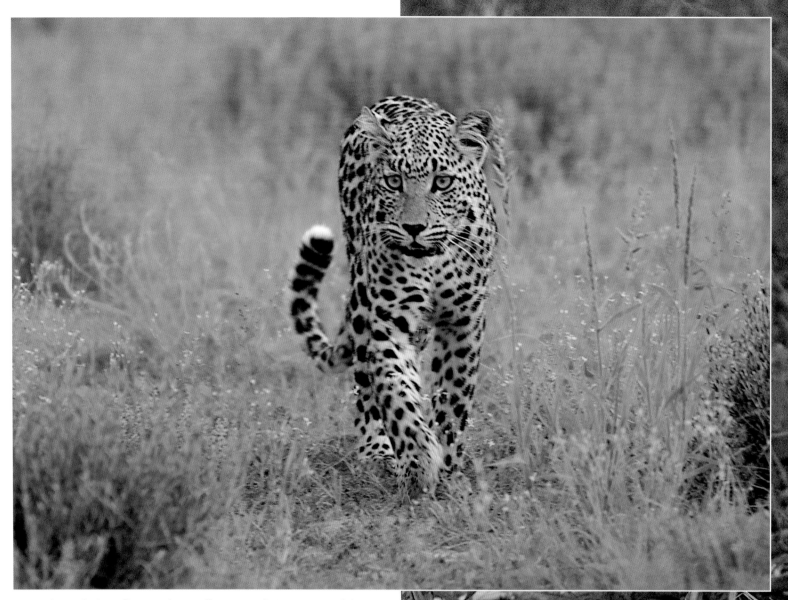

Leopards are elusive, solitary and generally nocturnal. You may spend days in ideal habitat and not see one. Then suddenly, there it is. Despite many encounters over the years, I still have to remind myself to breathe when in the presence of a leopard.

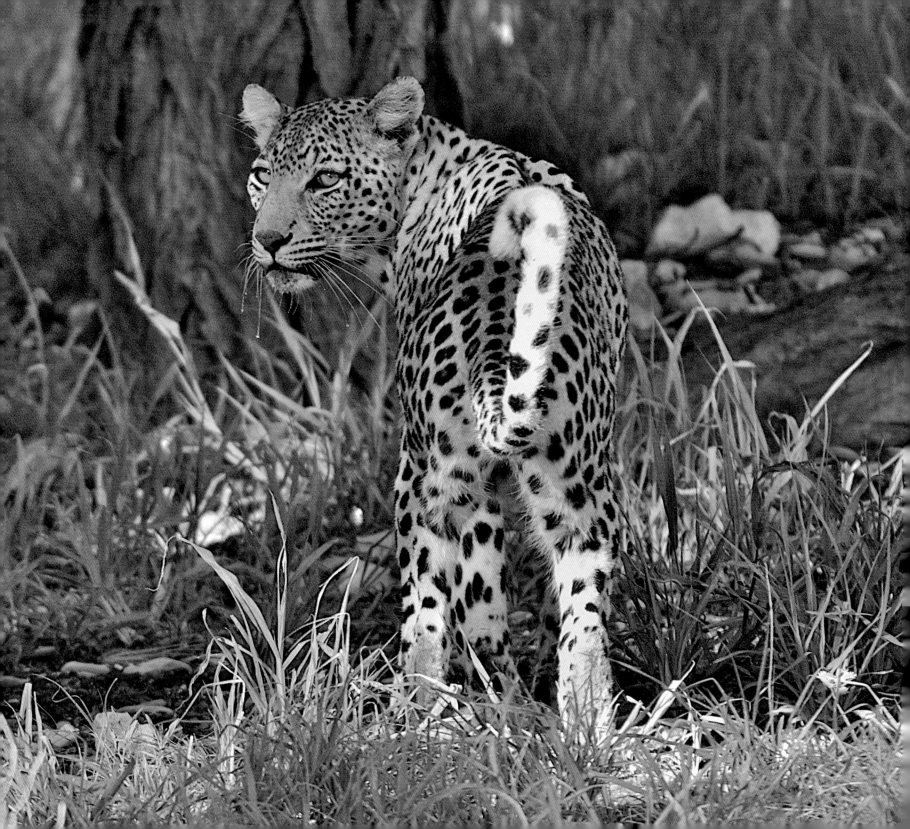

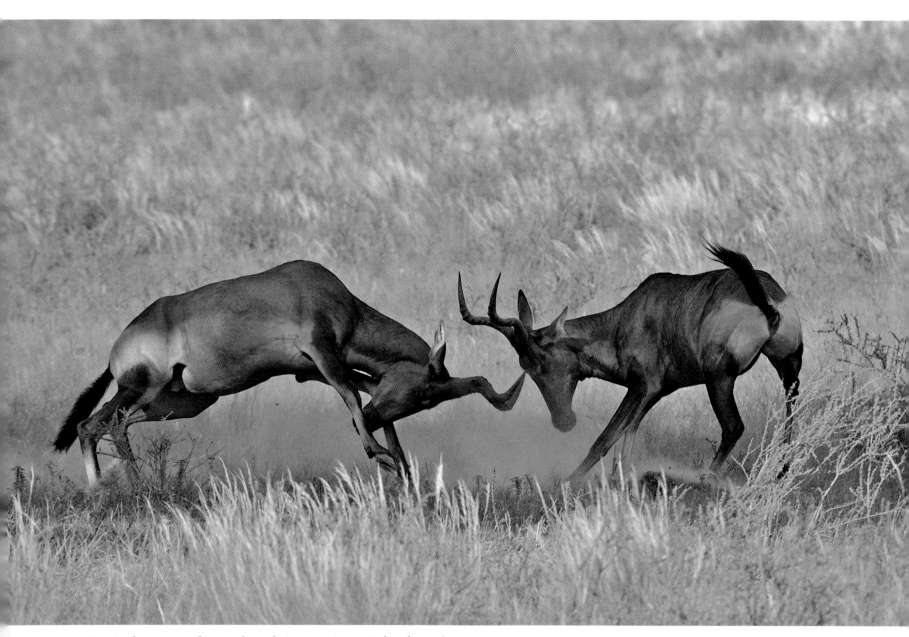

*Sparring between ungulates rarely results in serious injury. In fact, these red
hartebeest and the gemsbok shown opposite seemed to enjoy testing each other.*

OVERLEAF *A laughing dove basks in evening light.*

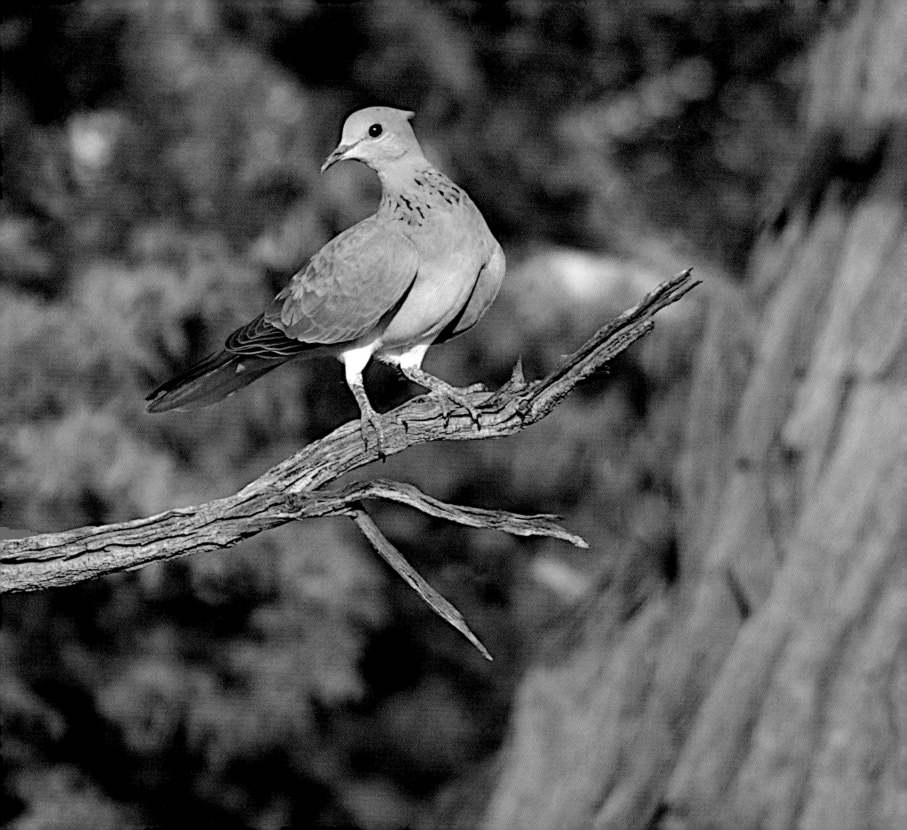

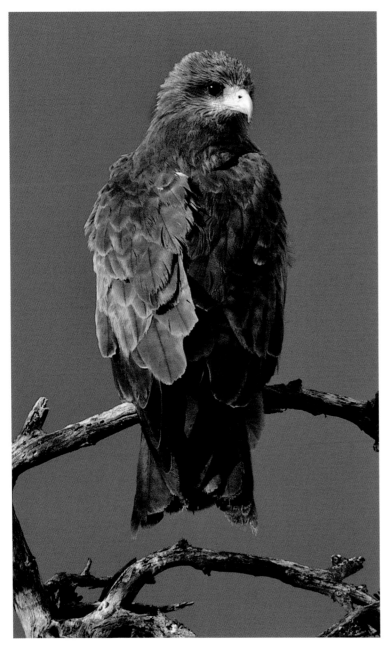

Yellow-billed kite

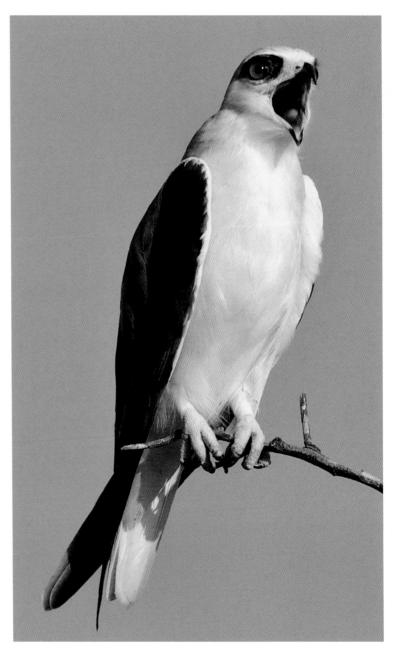

Black-shouldered kite

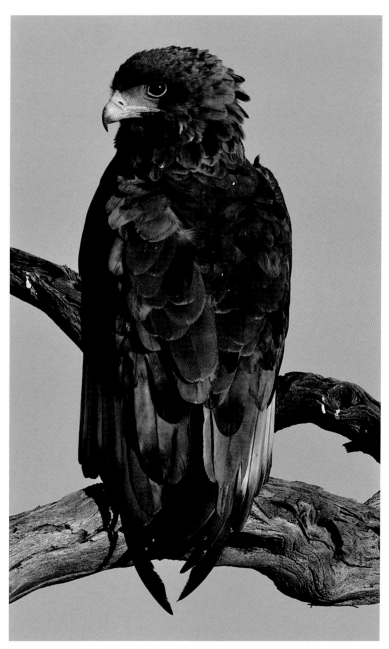

Bateleur subadult

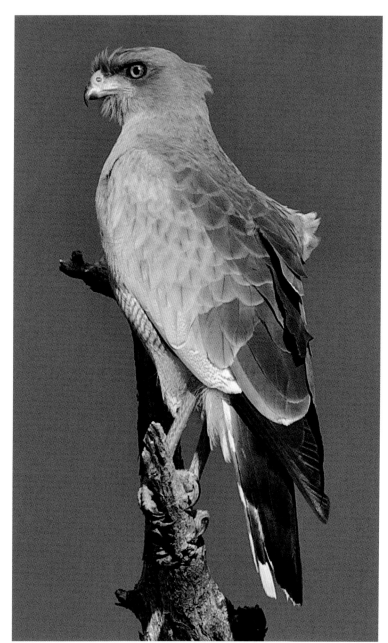

Pale chanting goshawk

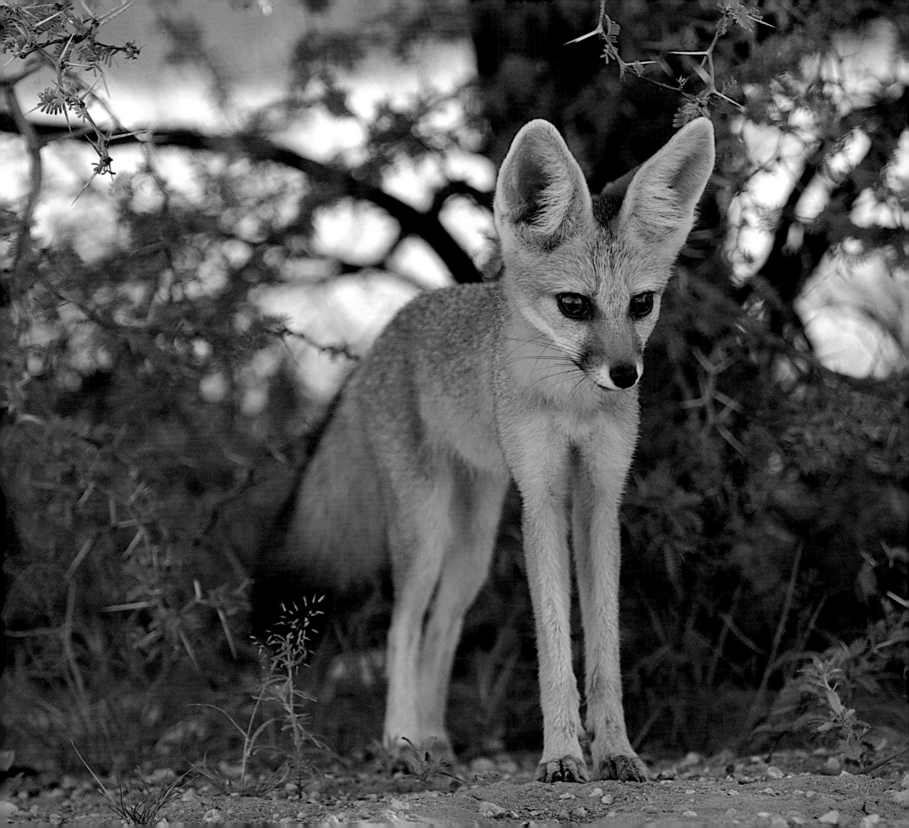

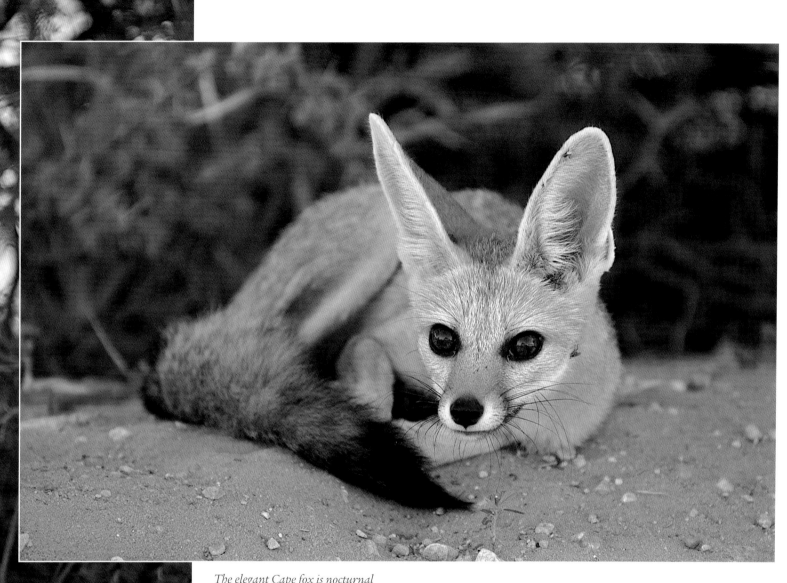

The elegant Cape fox is nocturnal and spends most of the day in its den or under cover. Occasionally one spots these foxes if the den is fairly close to the road. The wide-eyed youngsters shown here were litter mates.

Leopards have an uncanny ability to live in close proximity with humans and have demonstrated a unique talent for adapting to man-made environmental changes. Sightings often last just moments, so I always enjoy reviewing my photos to remind myself of what I have witnessed.

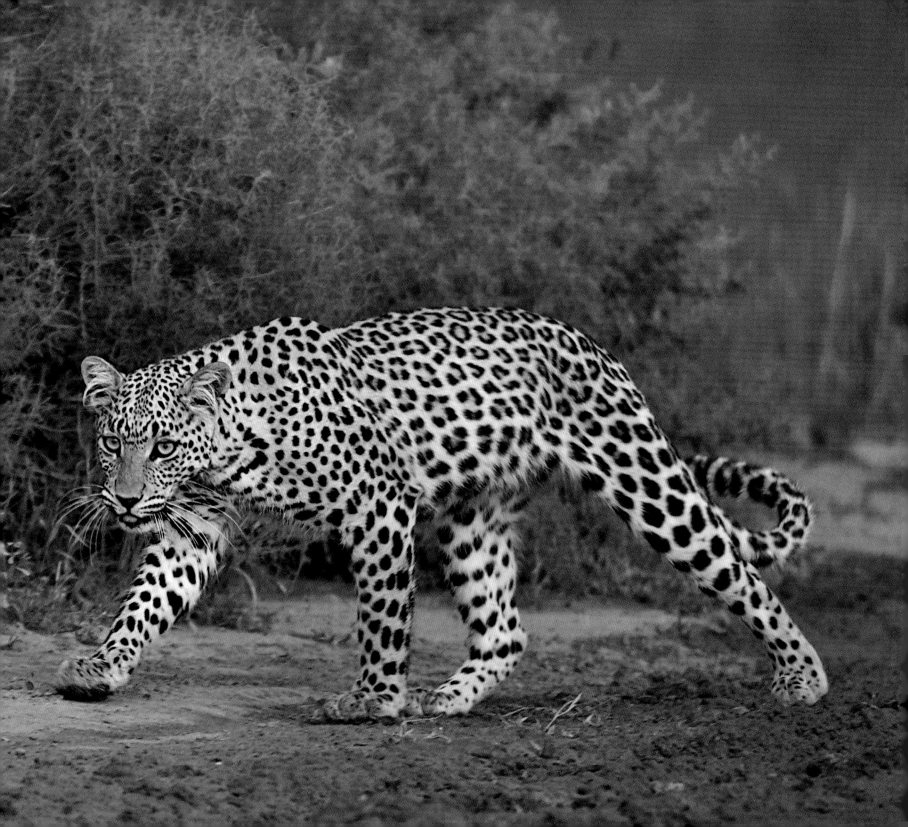

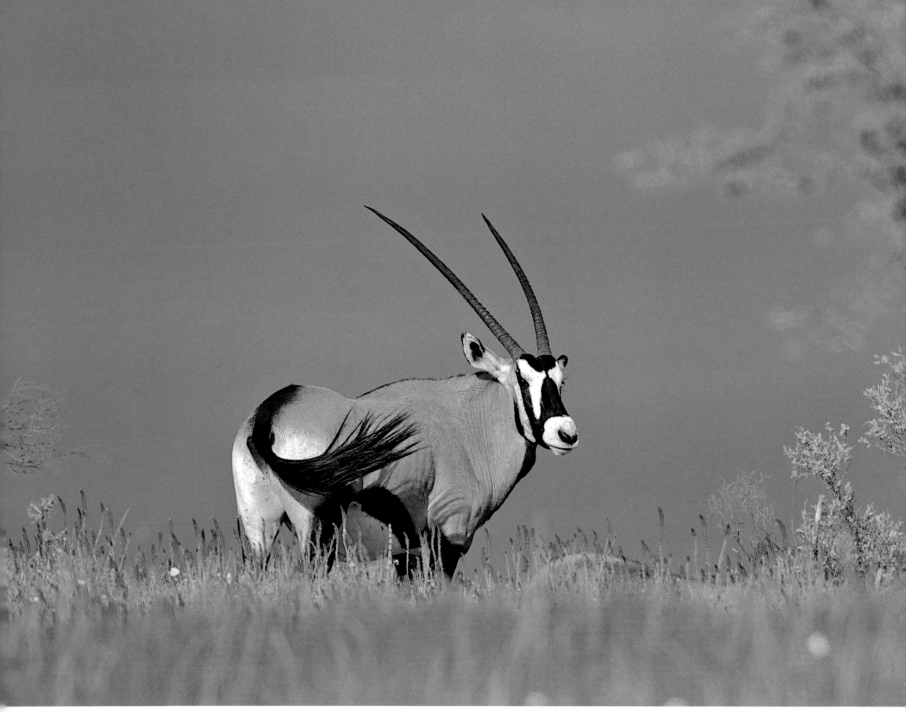

A gemsbok is set off by a darkening sky.

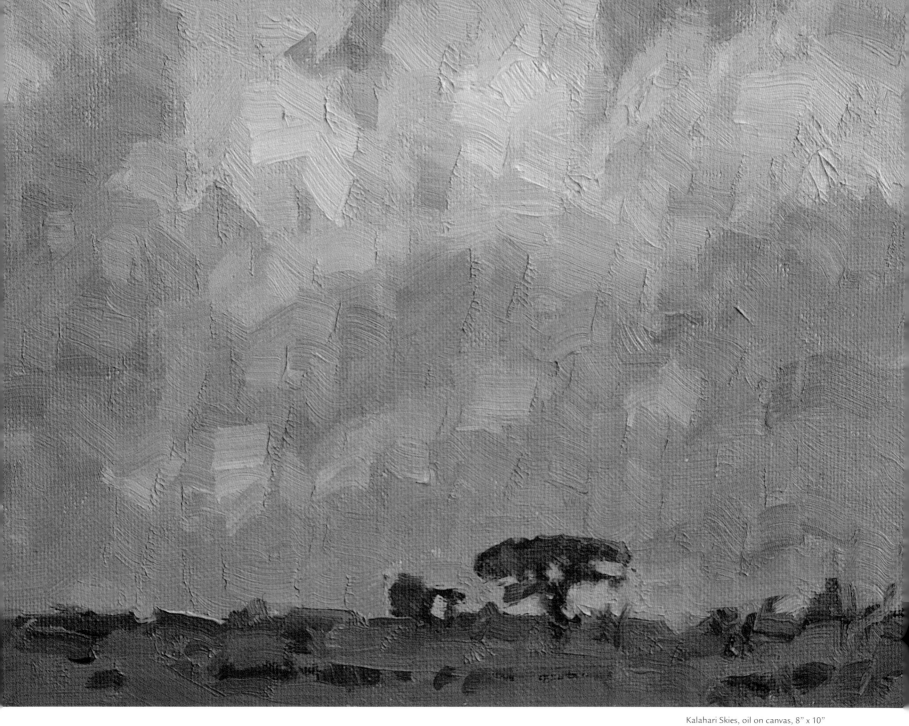

Kalahari Skies, oil on canvas, 8" x 10"

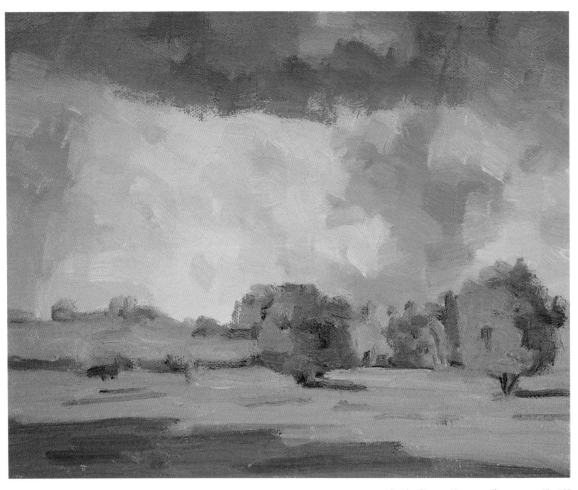

Passing Storm – Kamqua, oil on canvas, 8" x 10"

The red hartebeest favours grasslands within the drainage area of the Nossob but also occurs in smaller numbers elsewhere in the park. In taking this image, I was attracted by the contrast between the cool green shadows and the fiery red of the antelope's coat.

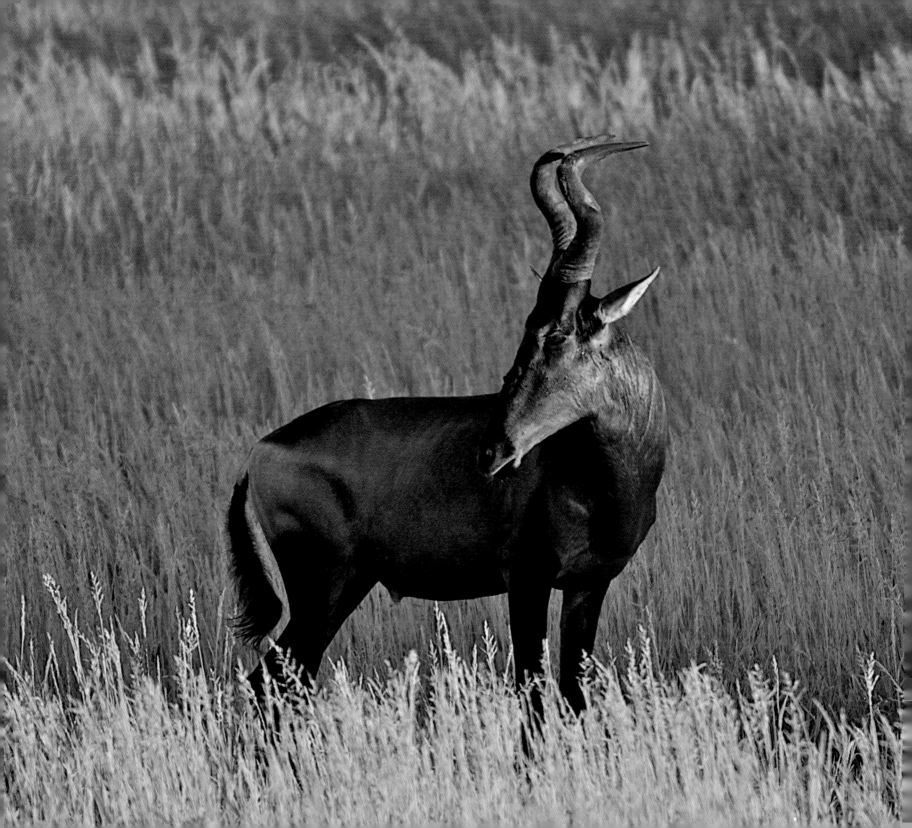

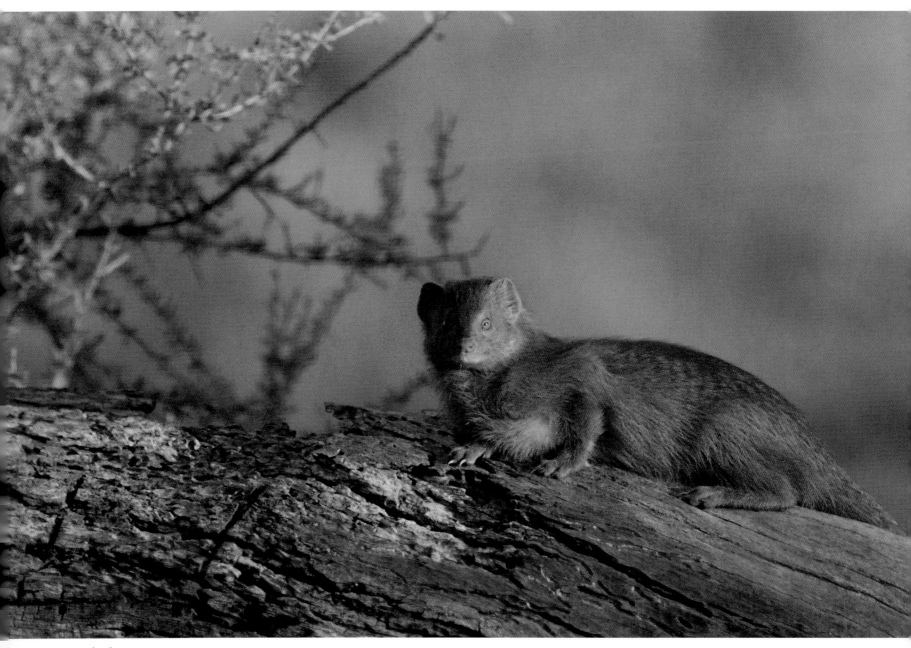

Slender mongoose

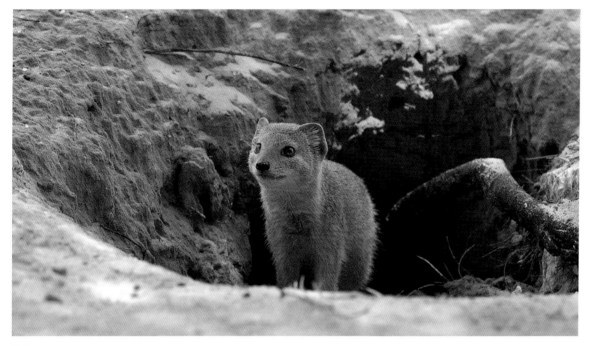

Smaller creatures add interest and diversity to the Kalahari's summer scene. Meerkats are especially common, but other species that soon become familiar to regular visitors include the slender and yellow mongooses, the ferocious honey badger and Brants' whistling rat, which is named for its shrill alarm call.

Yellow mongoose

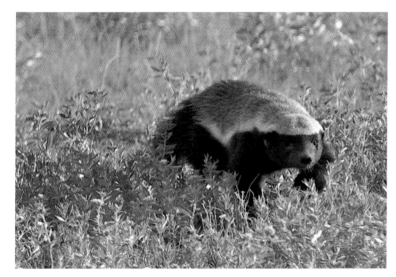

Honey badger

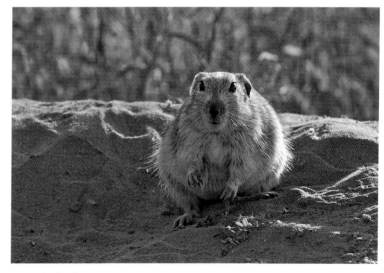

Brants' whistling rat

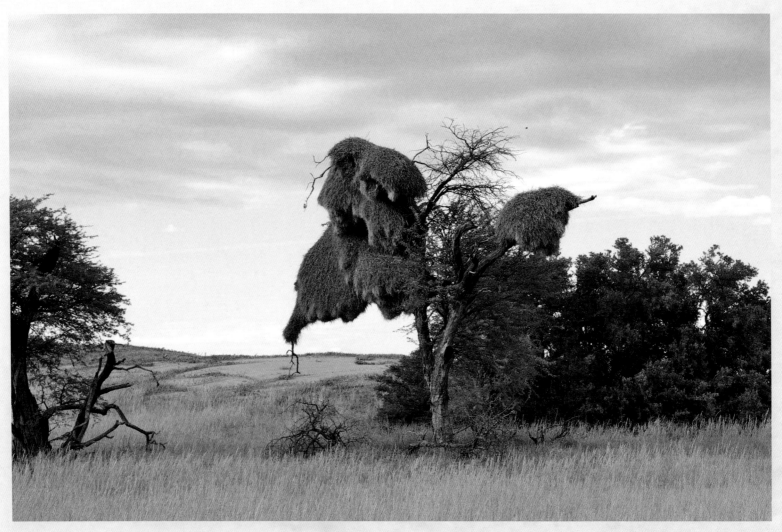

Cobra and weaver nest

Sociable weavers build enormous communal nests with hundreds of chambers.
They favour areas of short grass, possibly because these are less prone to fires. Cape
cobras, like the one shown opposite, frequently raid weavers' nests. The snakes take both
chicks and eggs, sometimes managing to destroy most of the young in the colony.

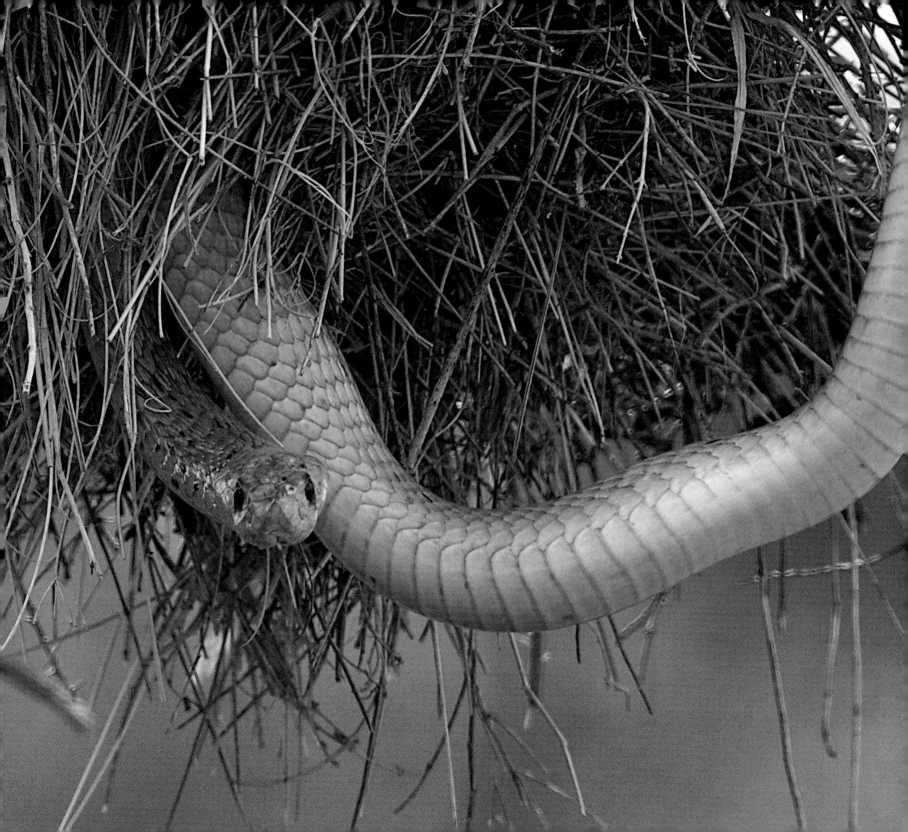

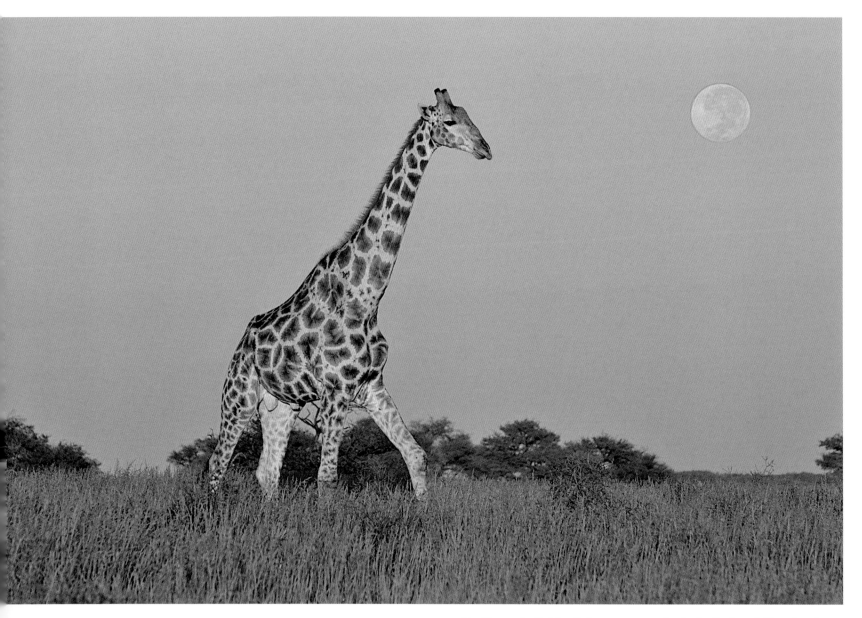

Giraffes are the Kalahari's largest prey species. In the Kgalagadi Transfrontier Park, they are found principally in the drainage area of the Auob River. The bull shown above appeared one morning, just as the moon was about to set in the west.

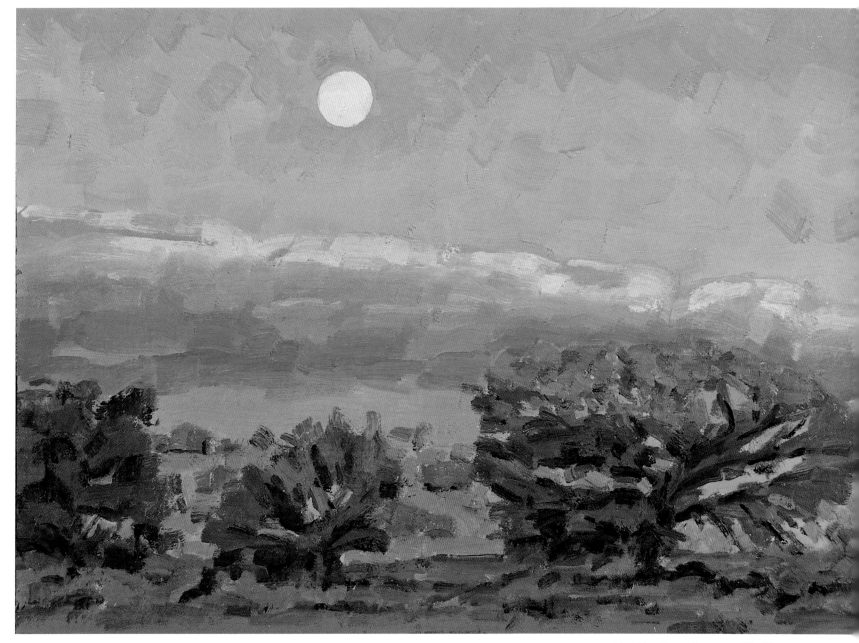

Mata Mata Moon, oil on canvas, 12" x 16"

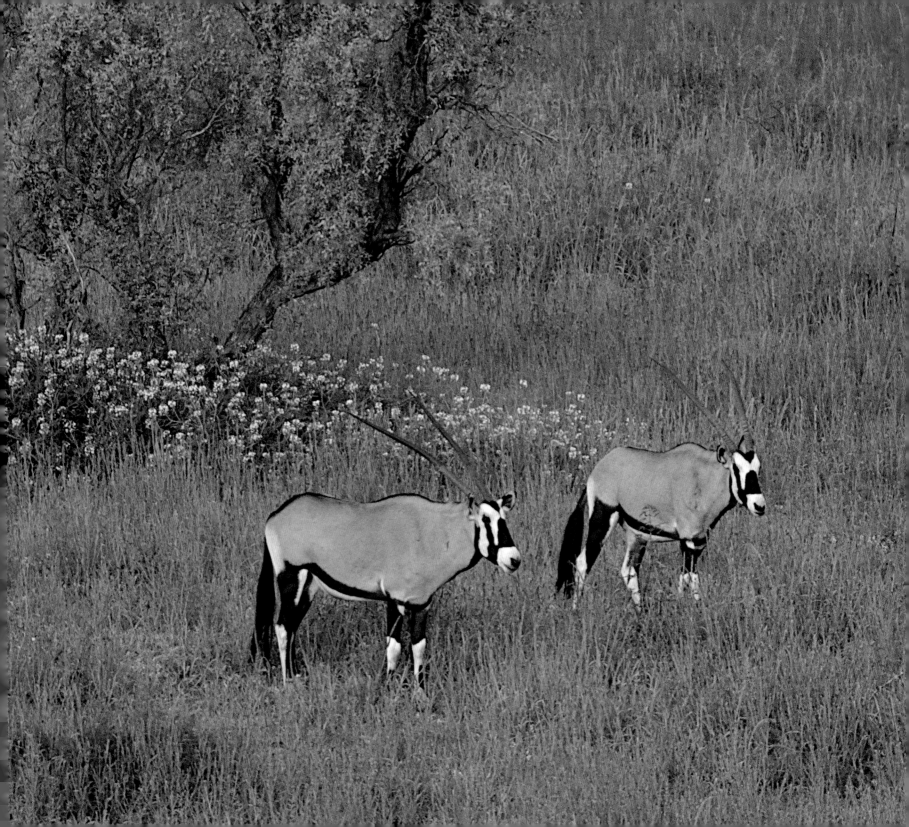

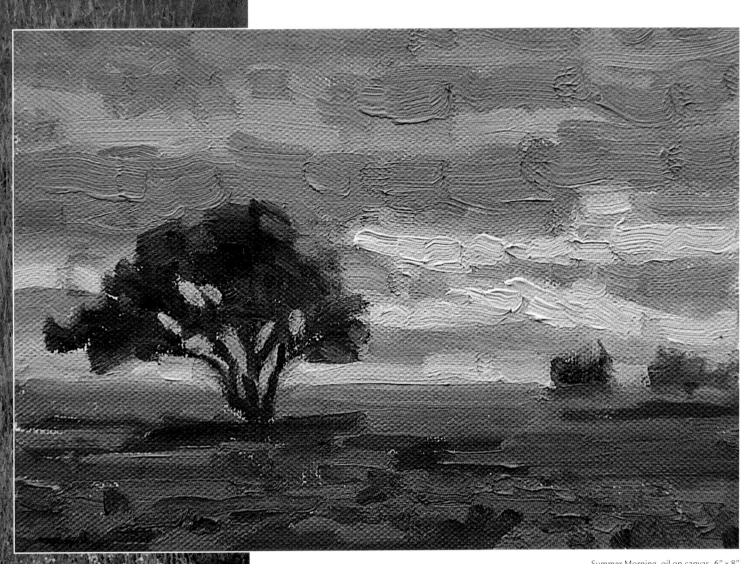

Summer Morning, oil on canvas, 6" x 8"

A pair of gemsbok pose in an expanse of cat's tail. What caught my attention about this scene was how beautifully the antelopes' dove-grey coats blend with the colour of the blooms. Gemsbok are another good example of antelope that do not require drinking water in their habitat.

63

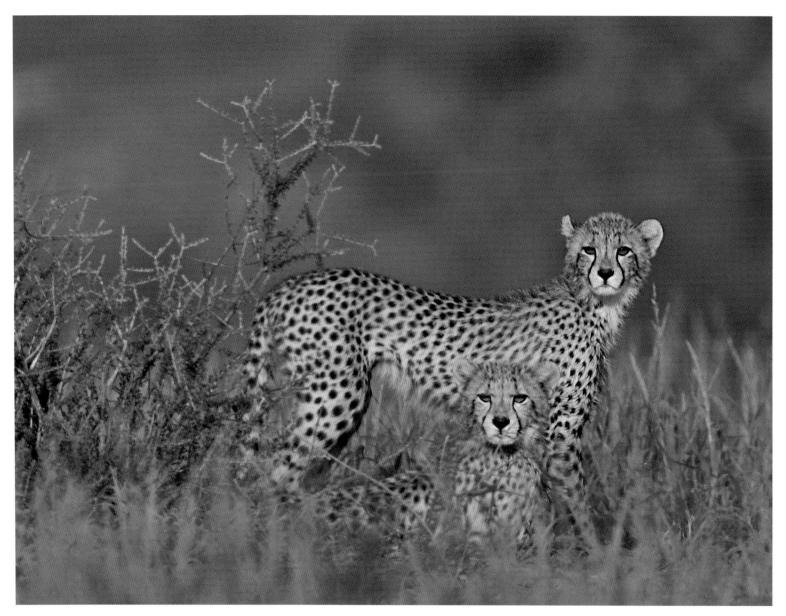

We came upon these cheetah cubs in some tall grass growing along the Nossob riverbed. One cub scampered clumsily up a nearby tree, but its sibling seemed to have second thoughts about following.

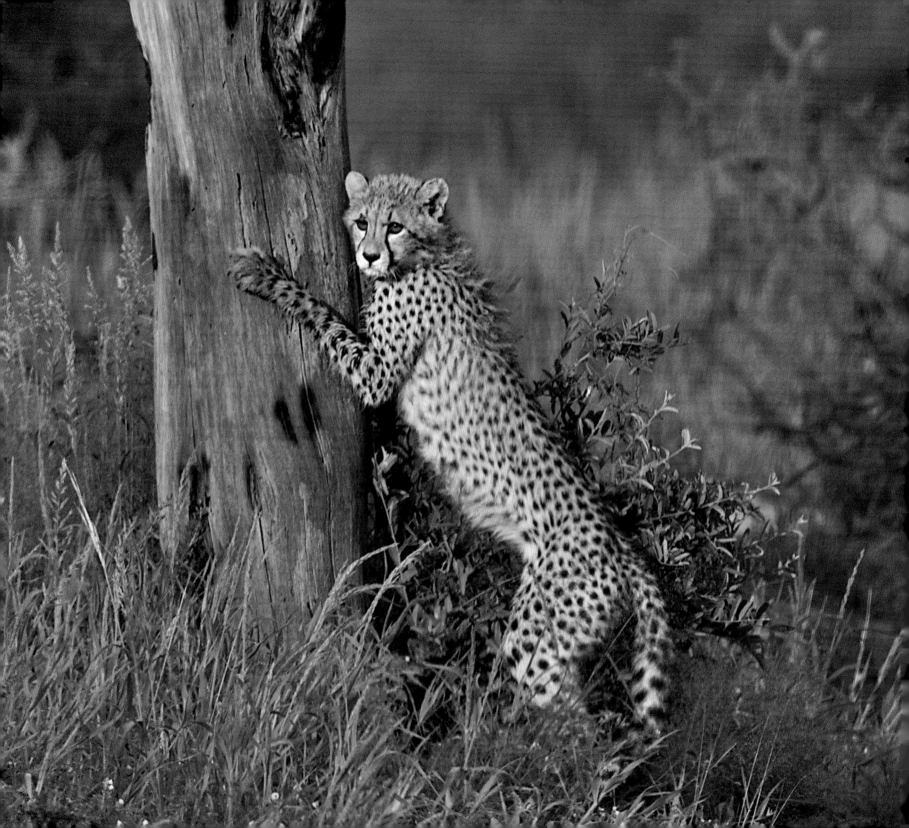

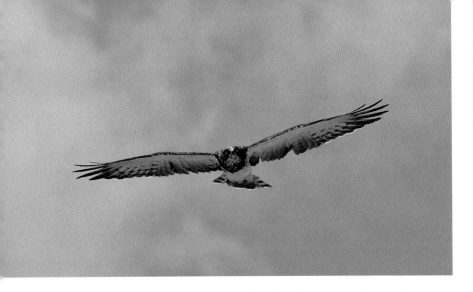

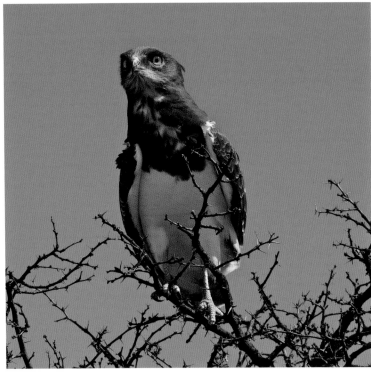

As its common name suggests, the black-chested snake eagle preys largely on snakes. The thick scales on its legs help to protect it from bites, and it often swallows its prey whole in flight. This bird always looks regal, whether gliding low in search of prey or perched against a magnificent backdrop.

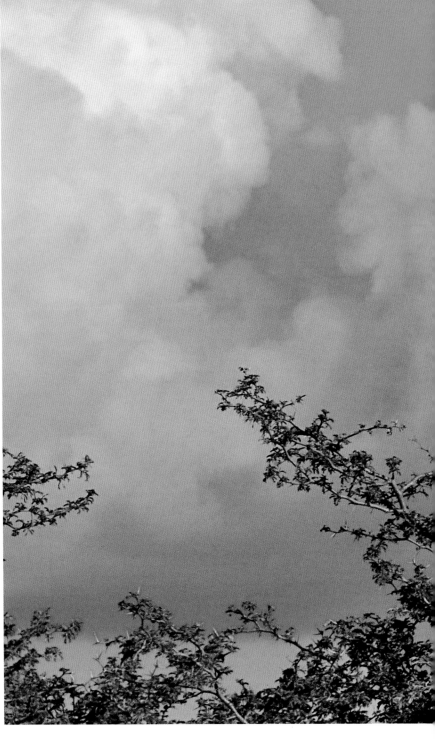

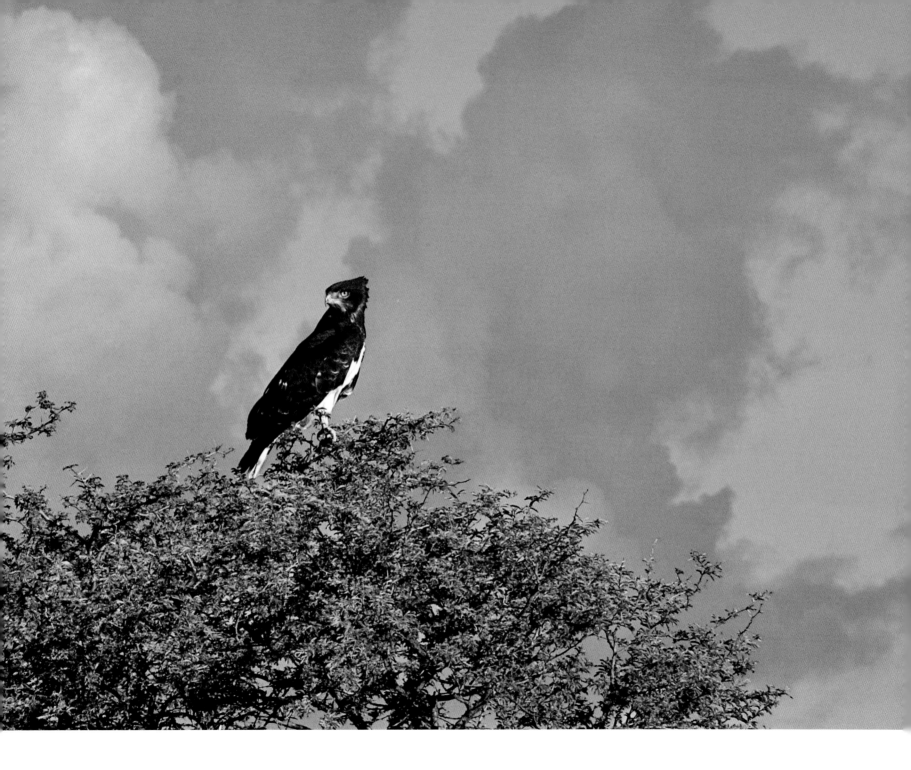

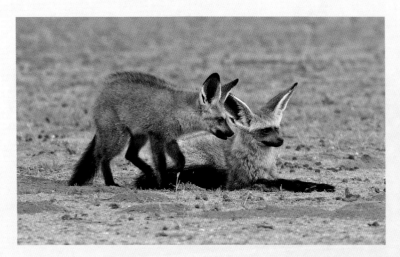

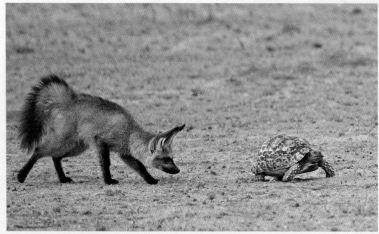

Fox meets tortoise

At dawn one morning we came across two bat-eared foxes with their offspring. When a leopard tortoise arrived on the scene, the adults gave it a cursory glance and then lost interest. The juveniles, however, had probably not encountered a tortoise before and were eager to investigate. Their cat-like fascination entertained us for some time before the tortoise managed to escape unharmed.

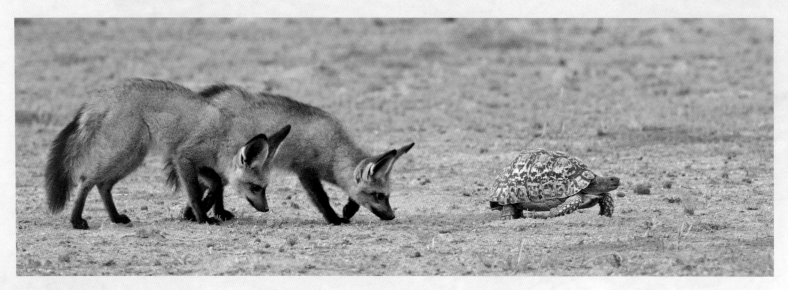

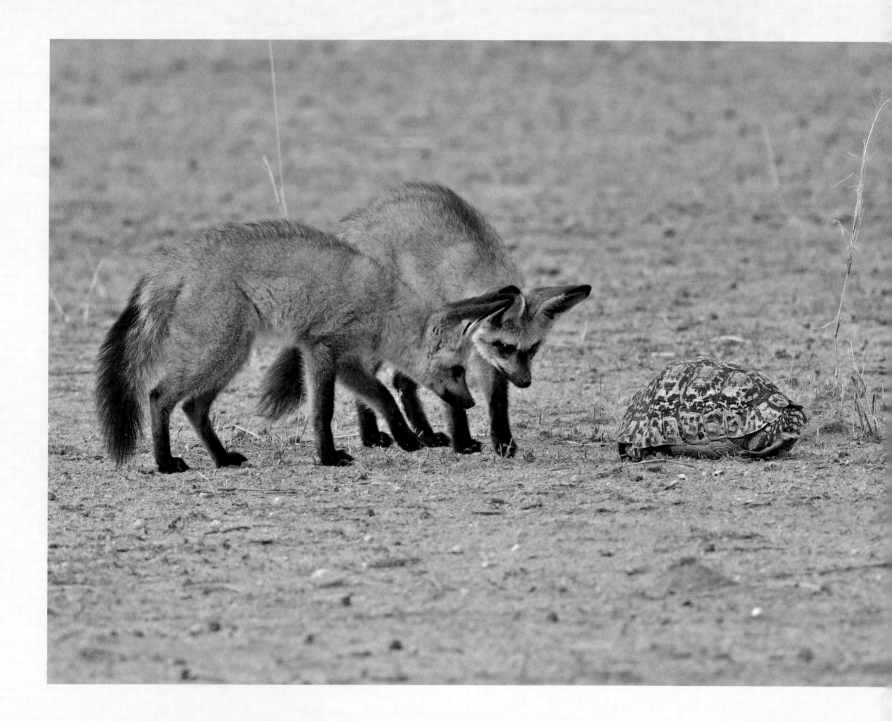

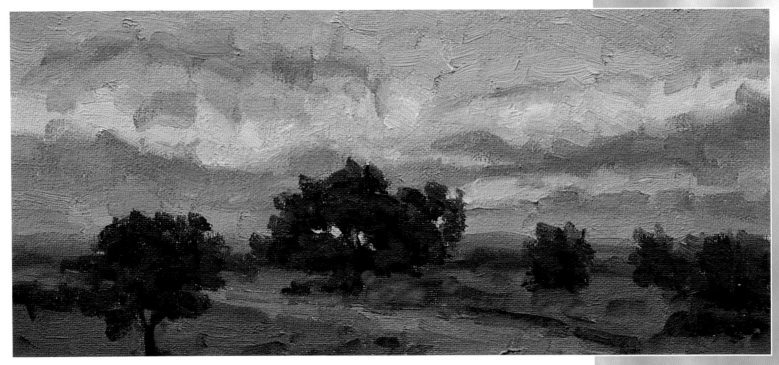

Kalahari Clouds – Study, oil on canvas, 6" x 12"

Cheetahs spend most of their waking hours scanning the environment for prey. In addition, they must keep watch for lions, which will not hesitate to kill other predators to eliminate competition for food.

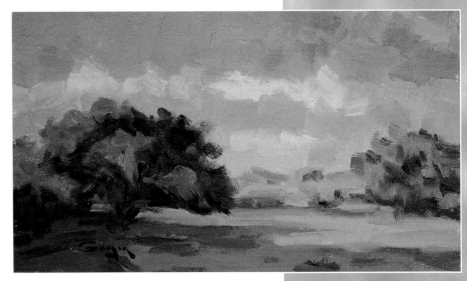

Sun and Shadow – Auob River, oil on canvas, 8" x 10"

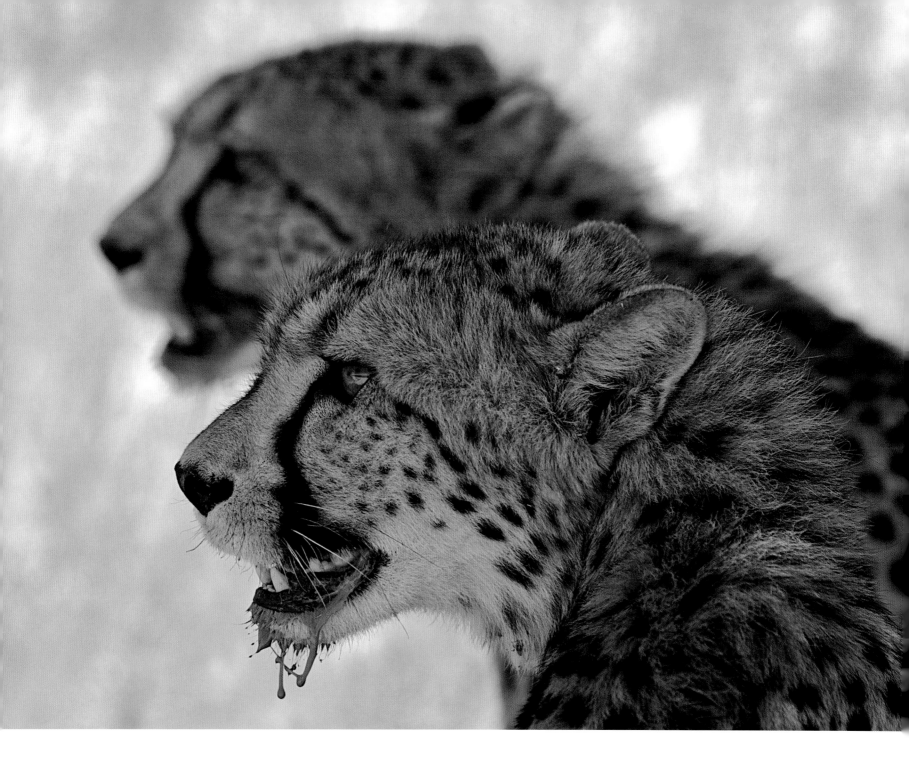

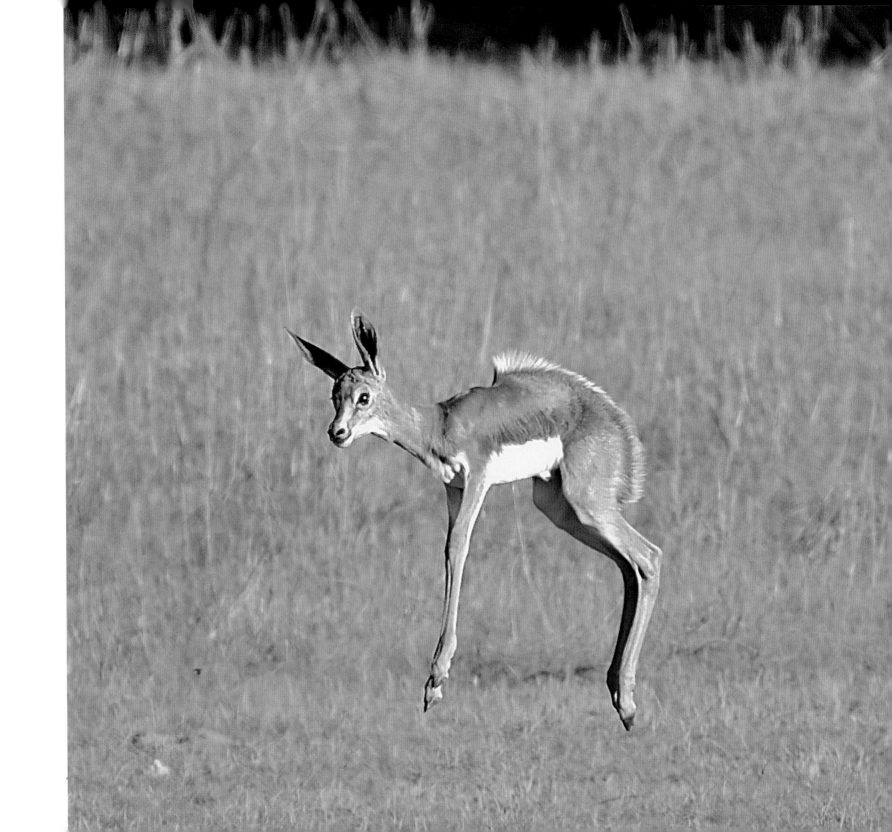

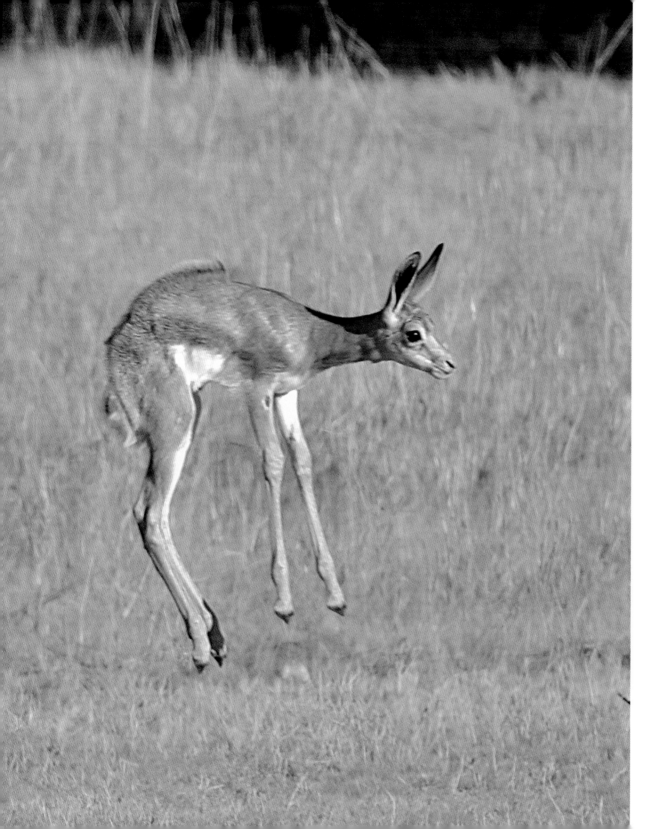

This pair of pronking springboks look rather like bookends. Watching these buck leaping, apparently for the pure joy of it, is always a feel-good experience. Since these two were relatively close together, I tried to catch them in the air simultaneously. I was lucky that it worked.

On-the-job training

One summer's morning we observed two large male cheetah cubs drinking from a puddle at the side of a track, while their mother kept a watchful eye on a springbok a fair distance away. Cheetahs generally get close to their prey before sprinting in, but on this occasion the female decided to launch an attack despite the distance. Seeing this, the cubs immediately bolted towards their mother. The cats and the antelope abruptly disappeared behind a dune. Lamenting the fact that we'd never know the outcome of the hunt, we turned our vehicle, only to see the springbok come charging out from behind the dune and directly towards us. The female cheetah managed to take the buck down in a cloud of dust, but presumably deciding that this would be a good training exercise for her cubs, she abandoned the springbok and retreated to a spot in the shade.

Though nearly full-grown, the cubs fumbled with the antelope for some time until it managed to get to its feet and run closer to our vehicle. When it seemed that the cubs might not be able to bring the springbok down, their mother returned to assist them.

We left the family to their meal, wondering what the female had detected in the springbok to suggest that she would be able to catch it at such a distance.

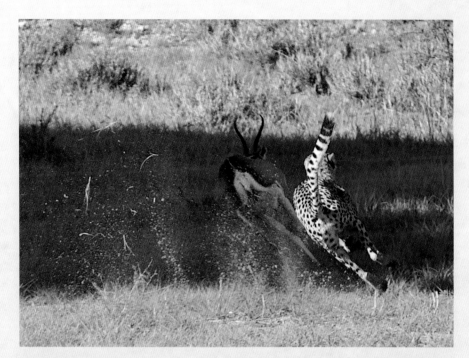

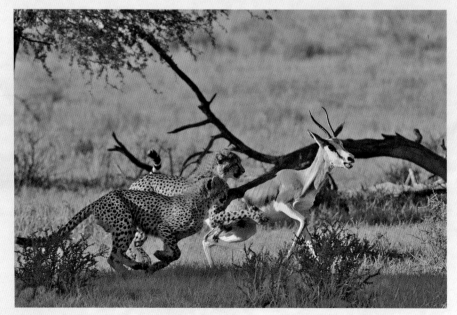

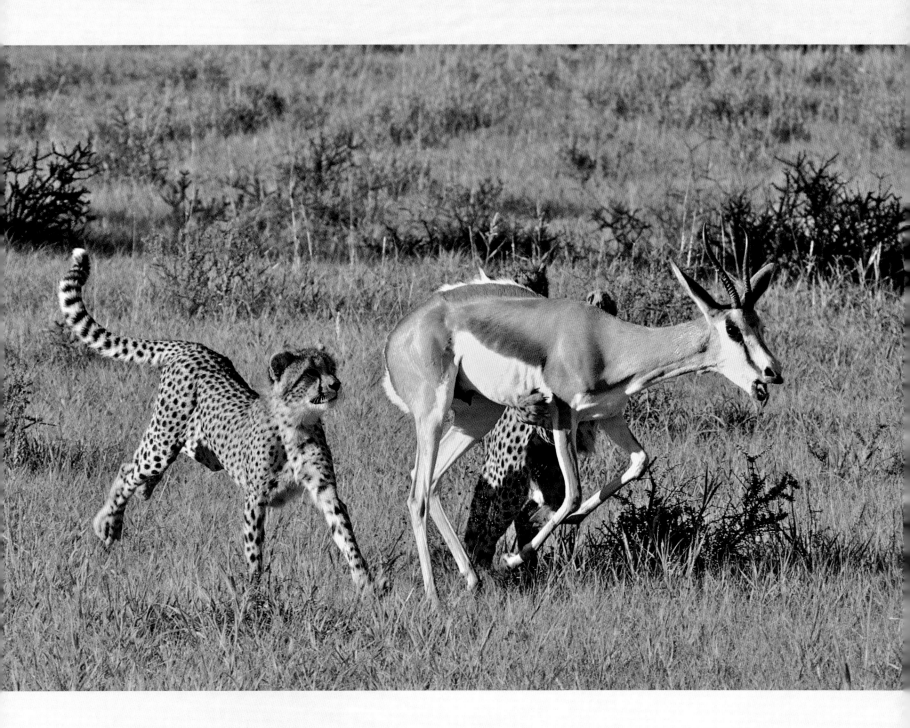

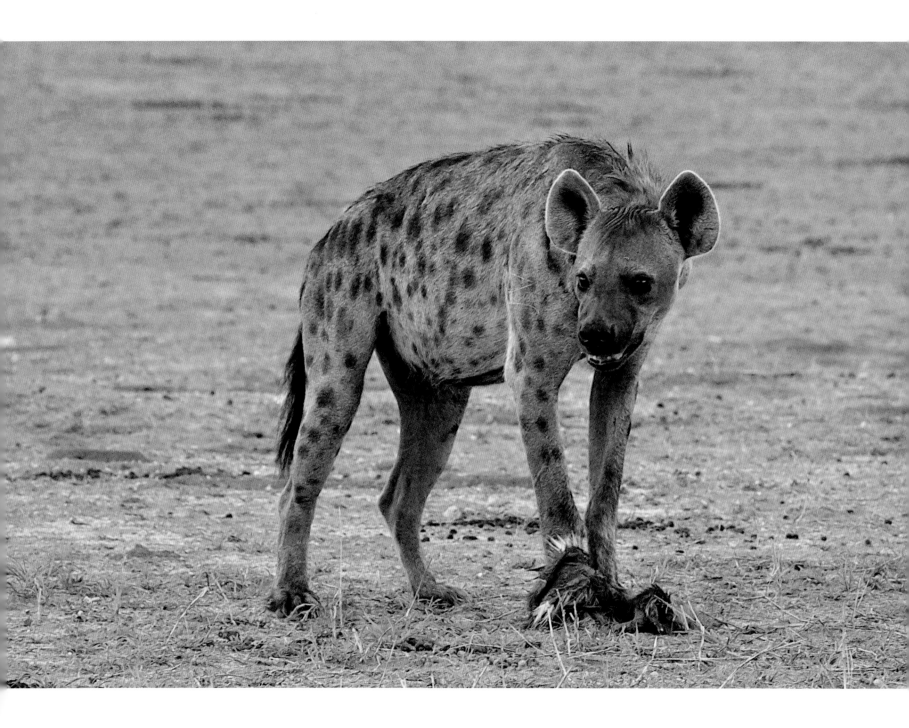

Spotted hyaenas, like the one shown opposite, are large, powerful, very vocal animals, with rounded ears. This individual was toying with some dry hide, all that remained of a recent kill. Although nocturnal, spotted hyaenas are regularly seen during the day. However, brown hyaenas, like the one below, are more strictly nocturnal. I was fortunate that this one was still active early one morning near Samevloeiing.

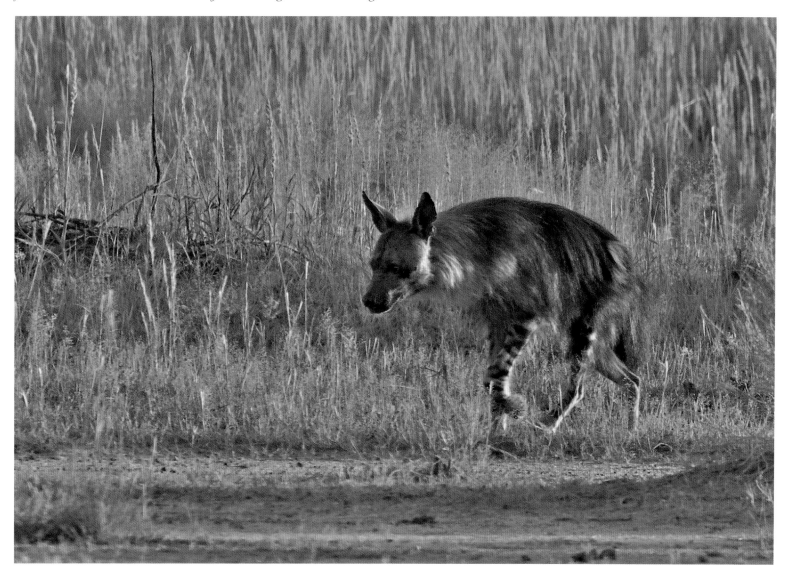

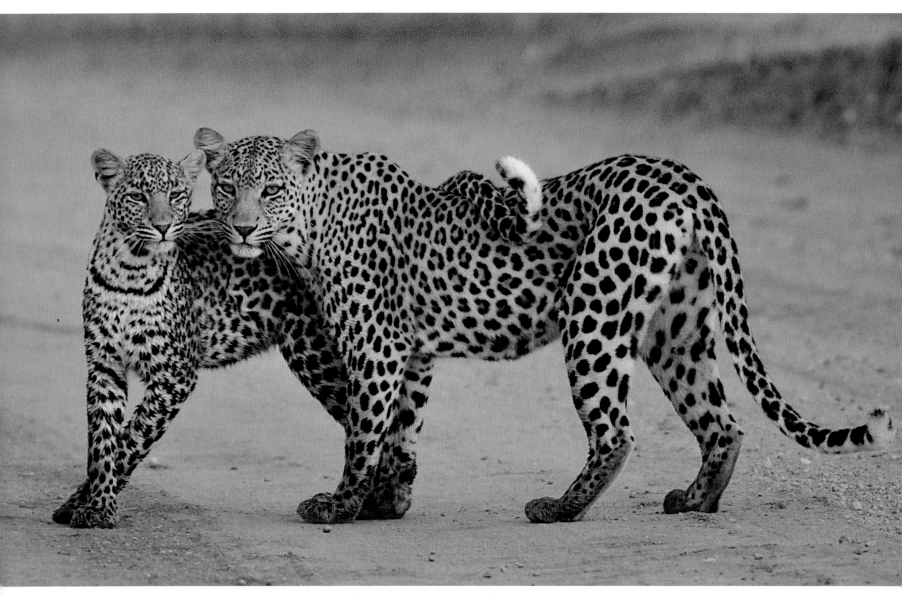

This small female leopard and her nearly grown cub travelled up and down the Auob valley together for over a week one summer. They proved a great source of entertainment as they took turns hiding and springing playful attacks on one another. The cub stalked everything that moved, from ground squirrels to giraffes. She even set her sights on a tawny eagle perched high up in a tree. Unfortunately the branches were far too slender to support her, and the hapless cub tumbled some distance to the ground. I finally caught them on camera one morning, looking rather sheepish, or so I thought.

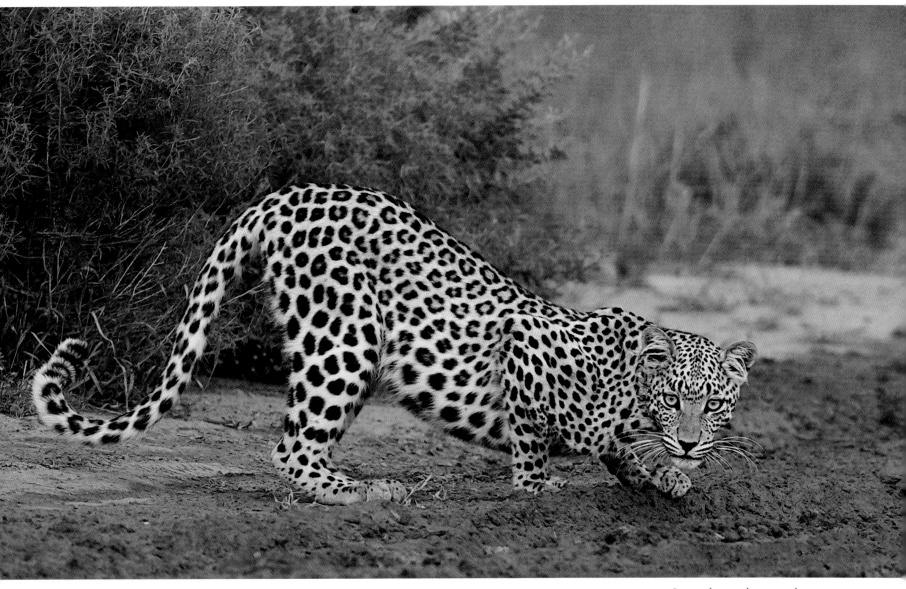

Leopards are reluctant to leave cover during daylight hours. If a leopard does not wish to be seen, you most probably will not see it.

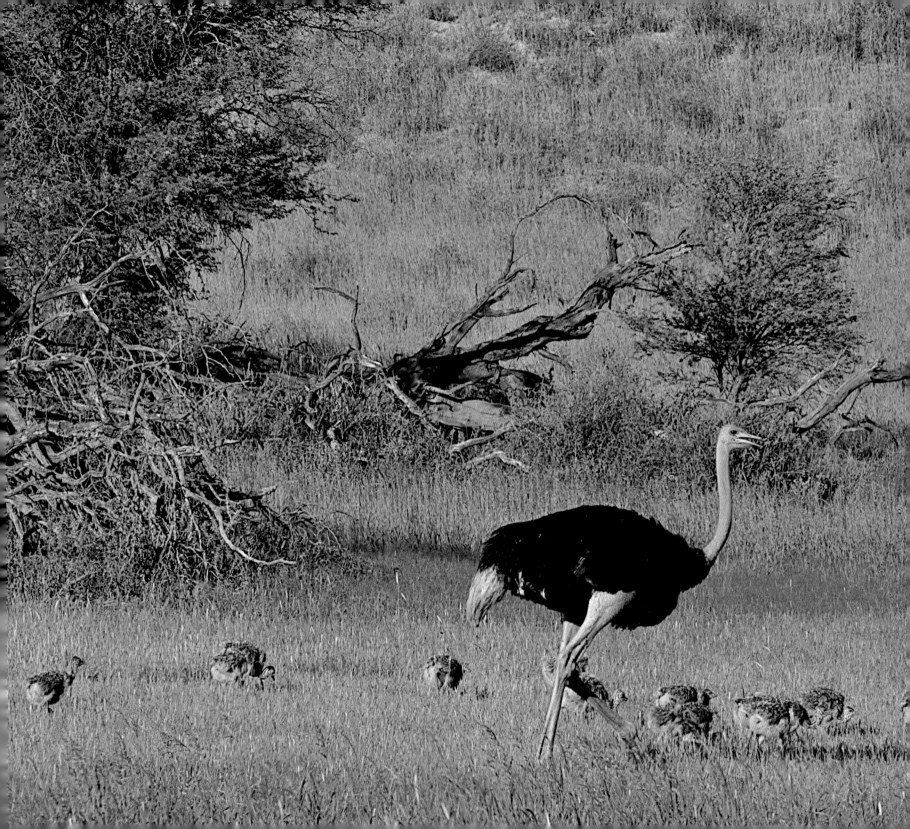

An adult male ostrich keeps watch over his large brood. Although both ostrich parents are defensive of their offspring, there is little chance that all the members of a clutch will survive to adulthood.

Water-hole drama

By midmorning, I'm often tired of driving and try to find a bit of shade at a water-hole, where I can wait and watch. At many water-holes, wave after wave of Burchell's and Namaqua sandgrouse drop in to drink, as was the case at the water-hole shown opposite. Often a flock of nervous grouse is on the ground for mere seconds before exploding skywards again.

 As the day heats up, other birds like the Cape Turtle Dove shown above also start arriving for water. Sensing safety in numbers, many more soon pour in. None of this is lost on the Lanner falcons, like the individual on the right here, observing from the trees nearby. When they can withstand temptation no longer, the raptors rocket through the air, scattering birds in all directions. Most often, for all its trouble, a falcon is left with just a few feathers. After one of these strafing flights, the water-hole falls briefly and eerily quiet, but it's not long before birds start trickling back, and the process repeats itself.

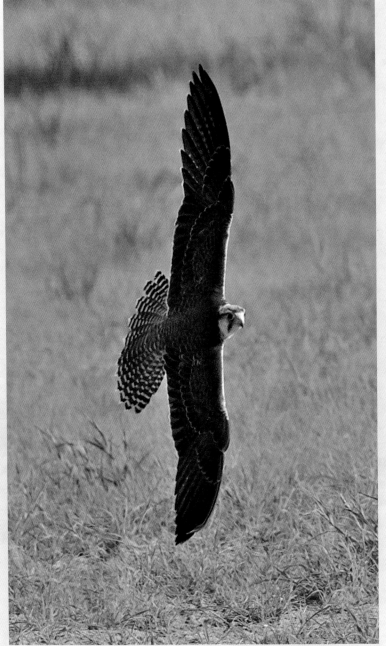

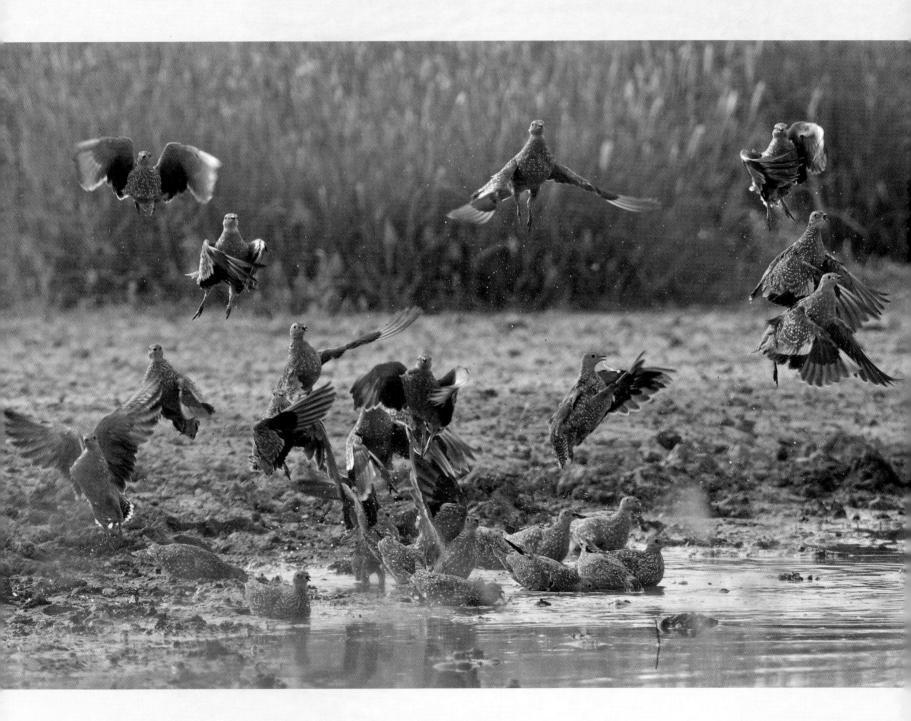

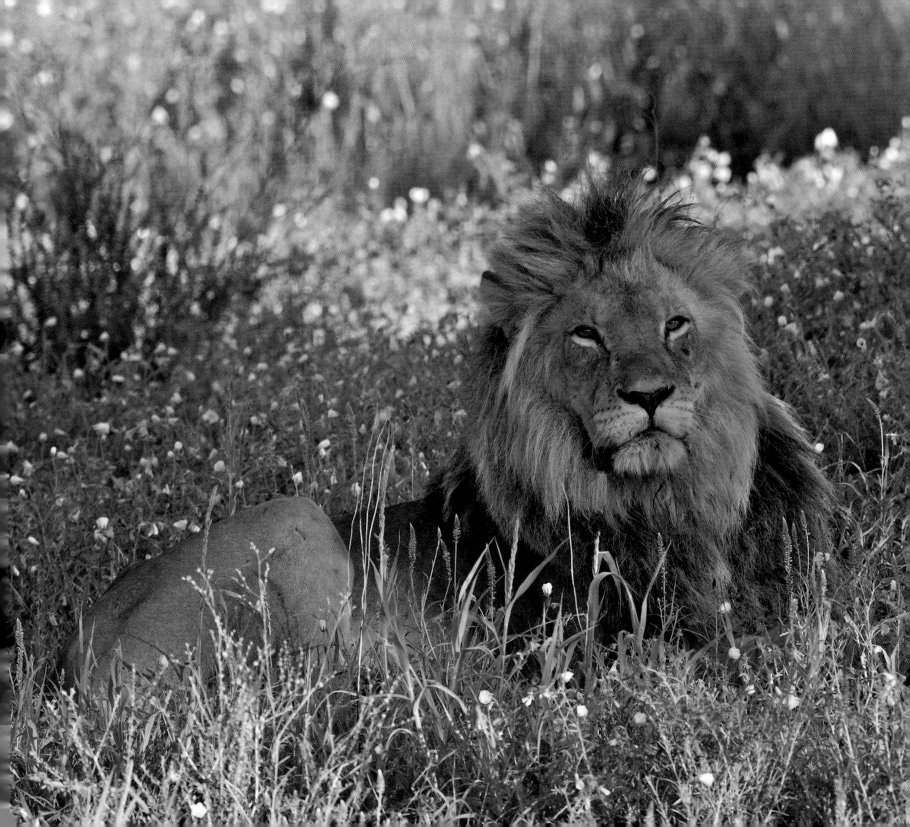

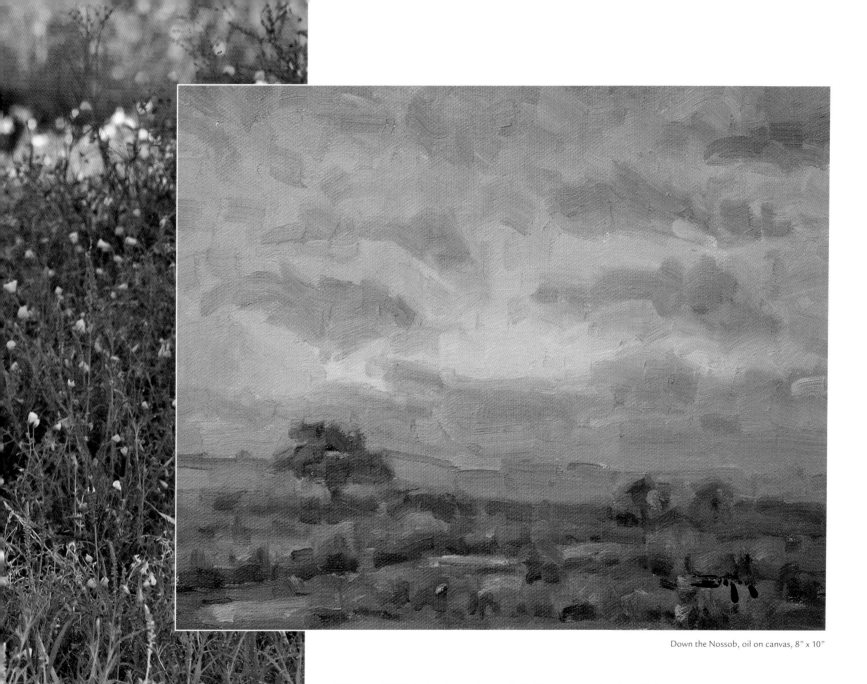

Down the Nossob, oil on canvas, 8" x 10"

This grand Kalahari pride male may look like a tame animal specially posed in a flower garden, but he is most definitely wild. Fortunately for me, he had flopped down in just the right spot for this whimsical photograph.

85

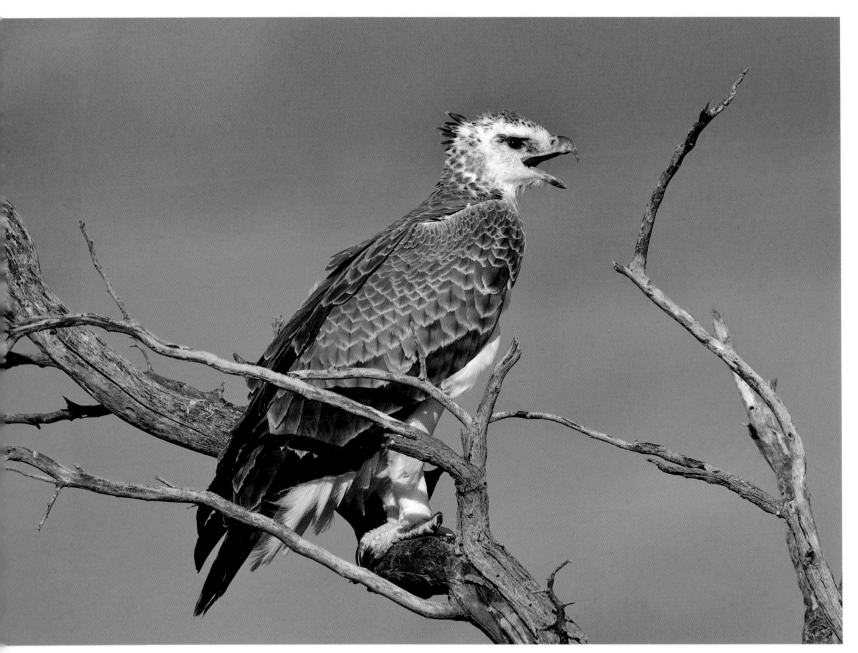

Martial eagles soar high overhead by day, preying on birds, reptiles and mammals up to the size of a small antelope. This is a relatively young bird.

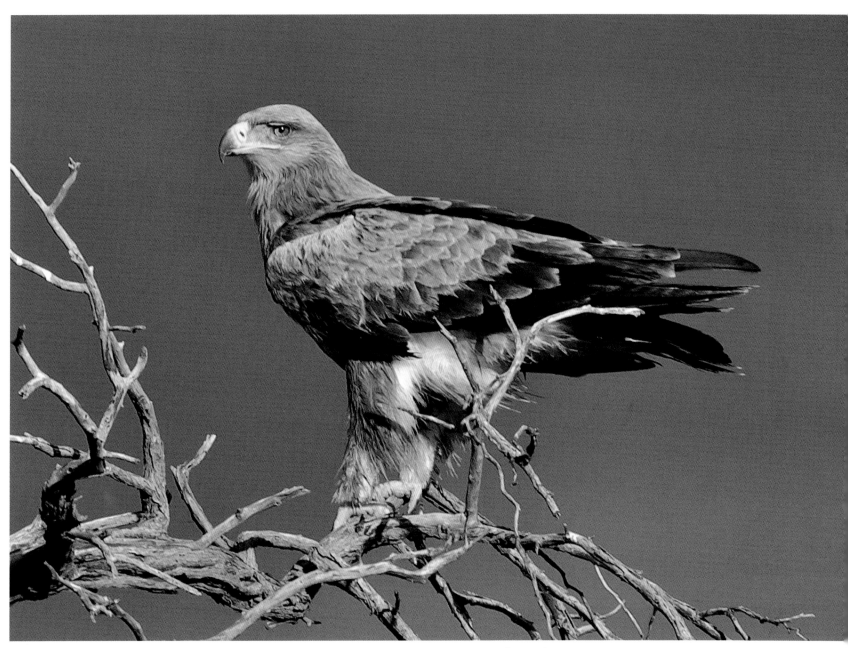

The shaggy-looking tawny eagle keeps a sharp lookout for small prey or for the chance to scavenge or poach a meal.

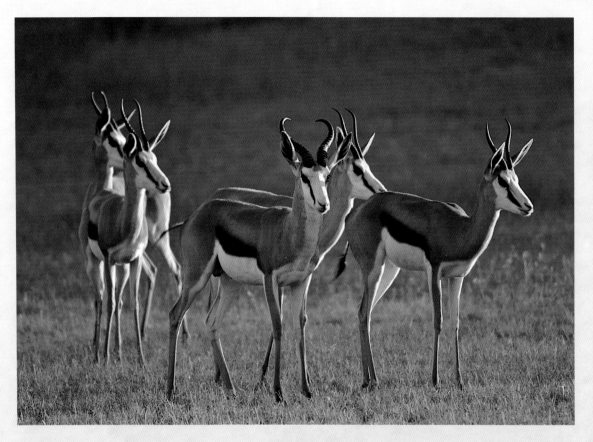

Heads up!

Since prey animals are constantly vigilant, watching their body language is an excellent way to spot predators. If every member of a herd is alert and staring in the same direction – like the springbok shown above – it is very likely that a predator is lurking. This is the moment when photographers need to be well prepared and very patient. Interestingly, prey animals will often stalk predators, coming as close as they dare. The young female leopard featured on the right had just killed and eaten a jackal. Though her sole interest was in reaching water, this small group of gemsbok snorted and stamped and challenged the leopard, taunting her and making it clear that she had lost any element of surprise. Unconcerned, the leopard continued without so much as a sideways glance.

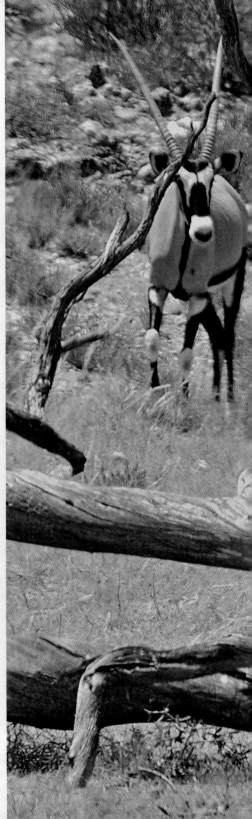

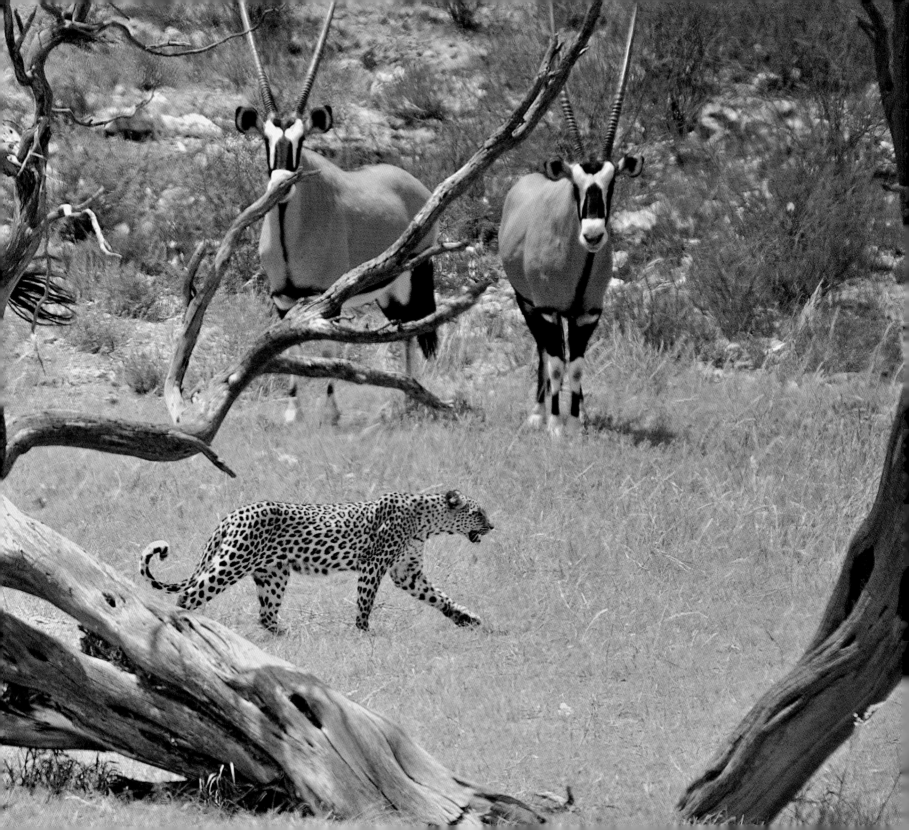

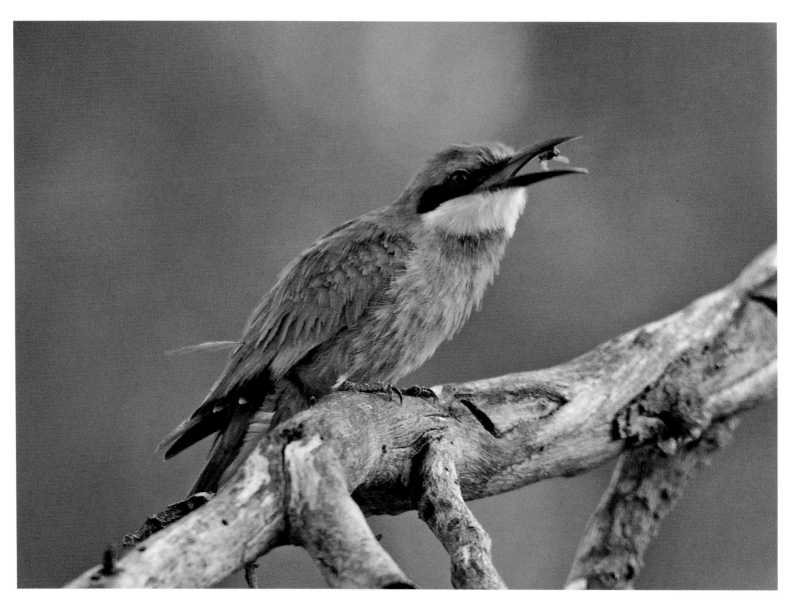

The lovely swallow-tailed bee-eater is the only bee-eater species commonly seen in the Kalahari. This bird is taxing to photograph, owing to its fast, erratic, swooping flight, but it is still among my favourite photographic subjects. Because the bee-eater tends to return to the same perch, a photographer's patience is occasionally rewarded.

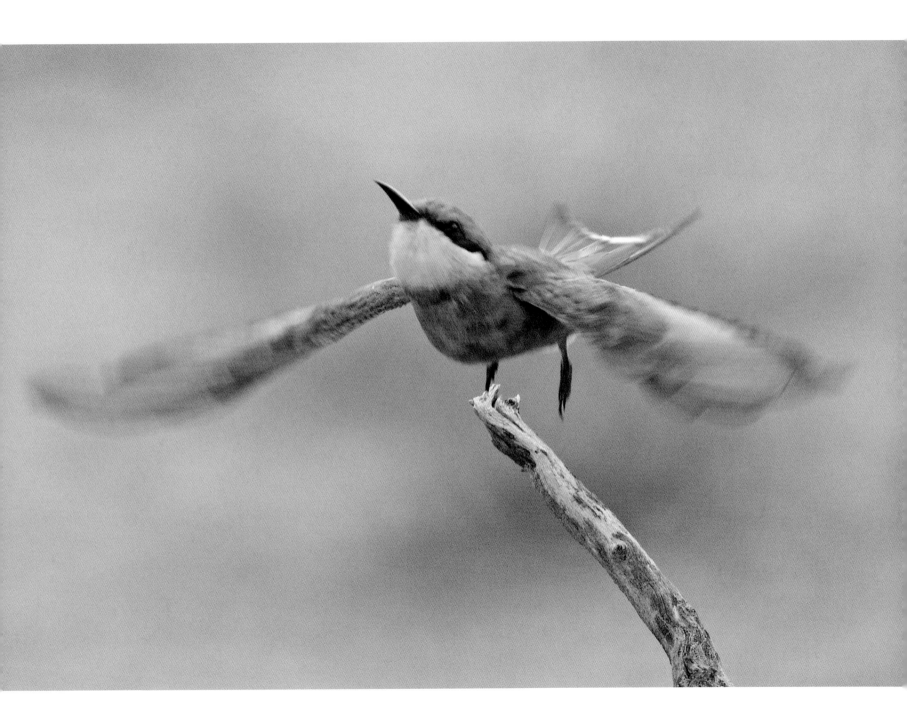

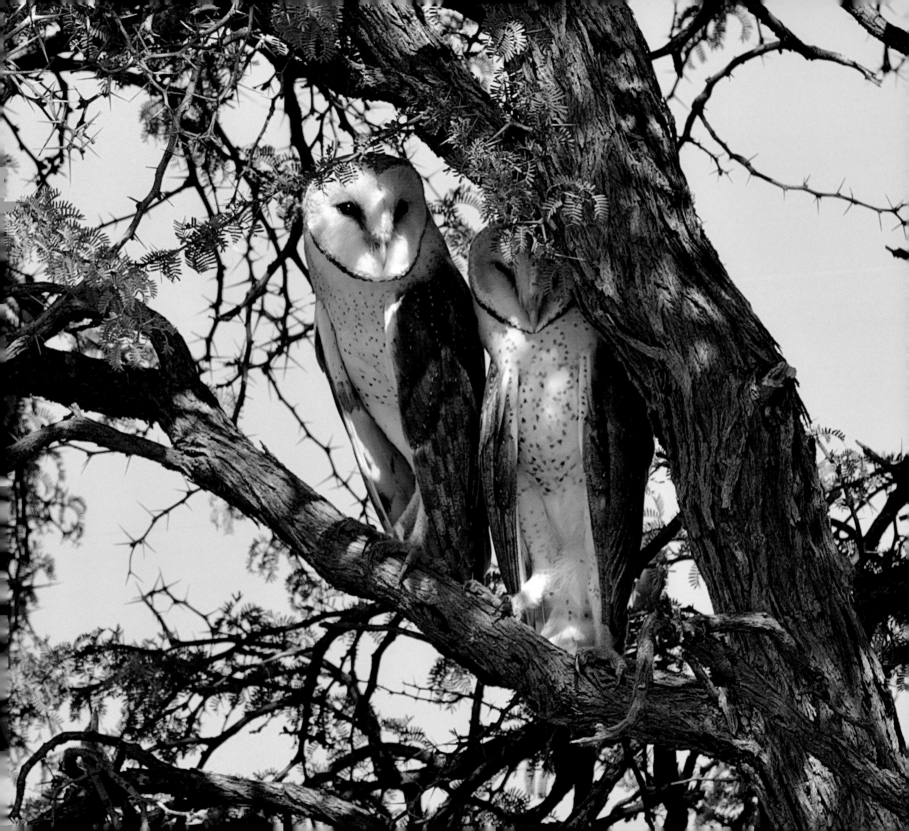

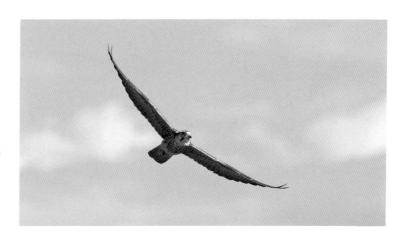

Raptors are more concentrated in the summer months. Shown to the left is a pair of Western barn owls perched in a tree, while the soaring raptor to the right is a Lanner falcon.

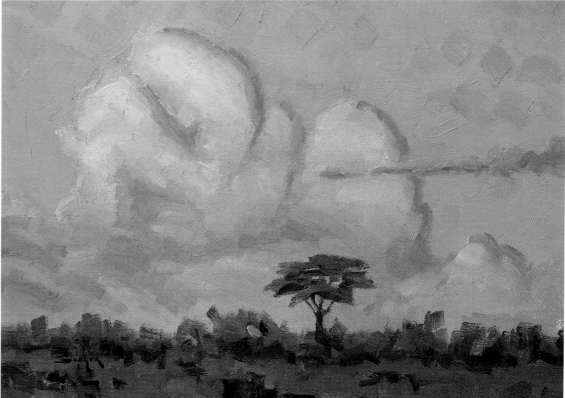

Urikaruus Cloud Study, oil on canvas, 8" x 10"

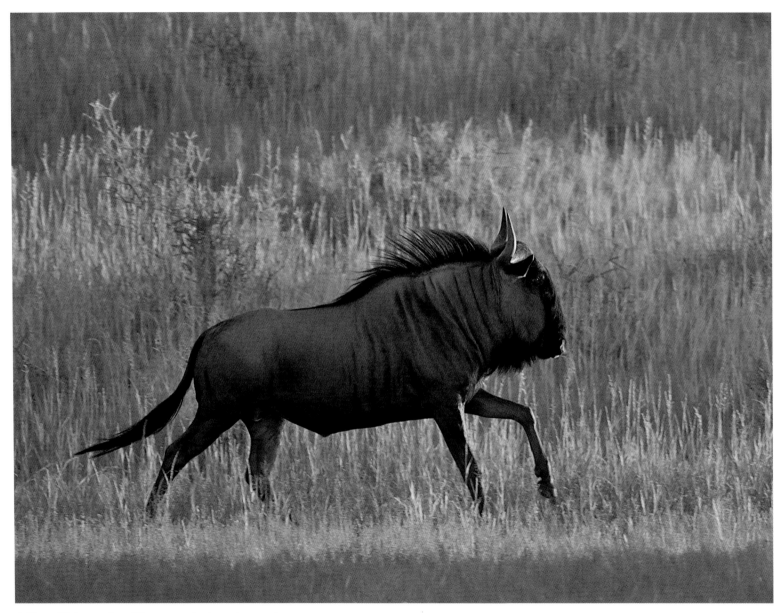

A blue wildebeest takes off into a run in the early morning. This particular antelope species is water-dependent and is constantly on the move in search of good grazing.

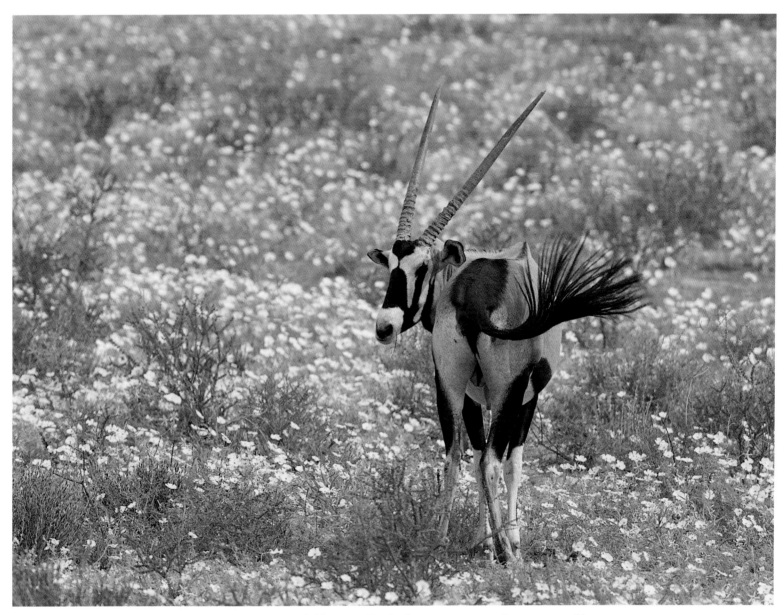

We often find ourselves comparing notes and photographs with fellow travellers back at our rest camp. The extravagant blossom in a scene like this one comes as no surprise to regular summer visitors, but for those who have previously visited the region only in winter, there is typically astonishment at the riotous colour. This gemsbok's striking markings help it stand out in the sea of yellow.

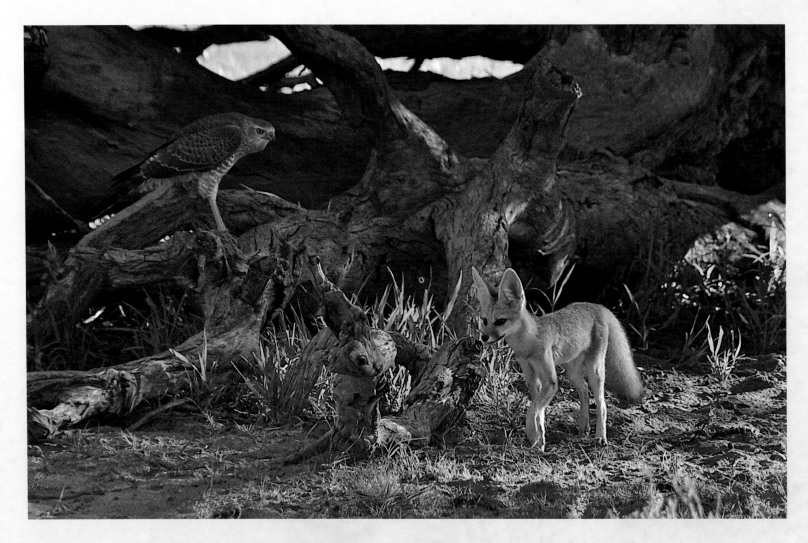

A juvenile standoff

Early one summer's morning I came across a pair of young Cape foxes that seemed to be litter mates. One of the siblings wandered off and unexpectedly stumbled upon a juvenile pale chanting goshawk perched on a nearby log. For some time neither party would retreat, until finally the goshawk spread its wings in an intimidation display that sent the inquisitive young fox scurrying for cover.

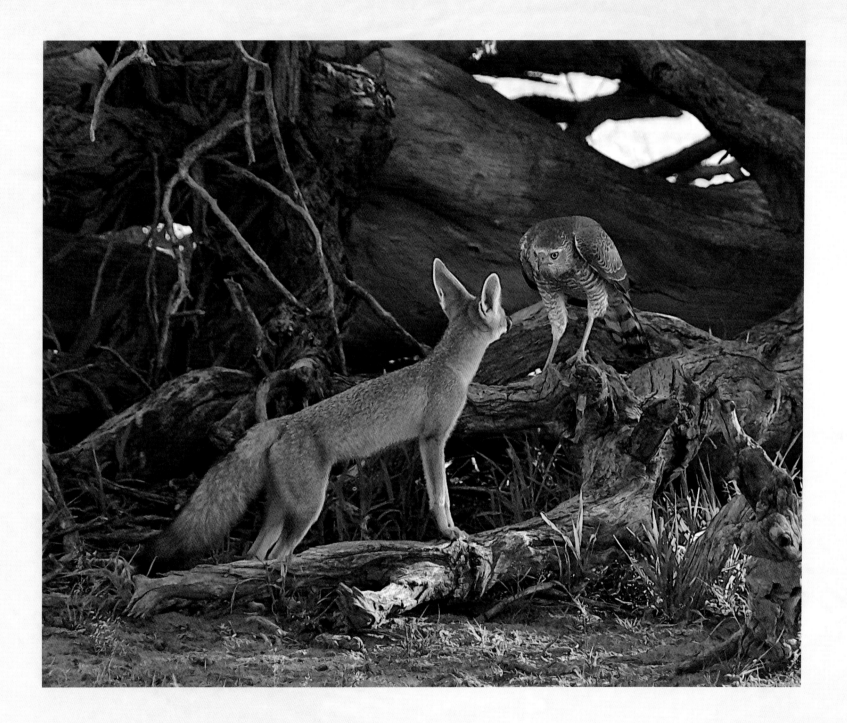

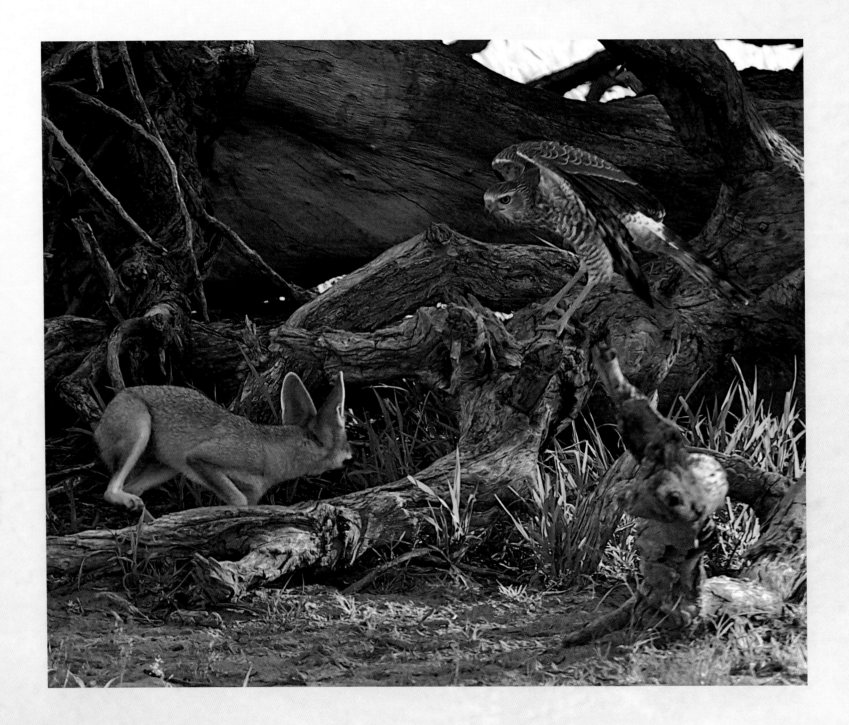

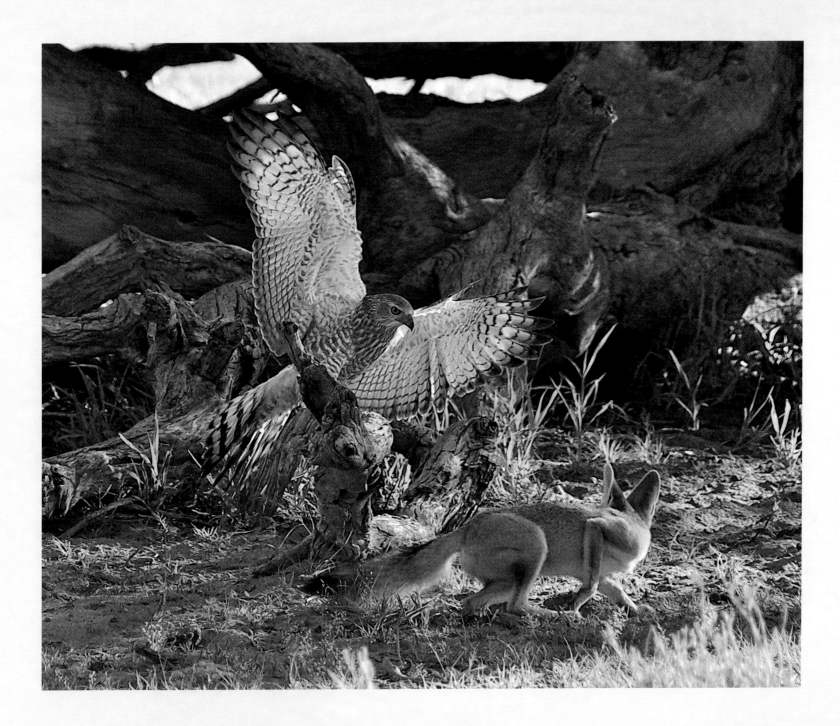

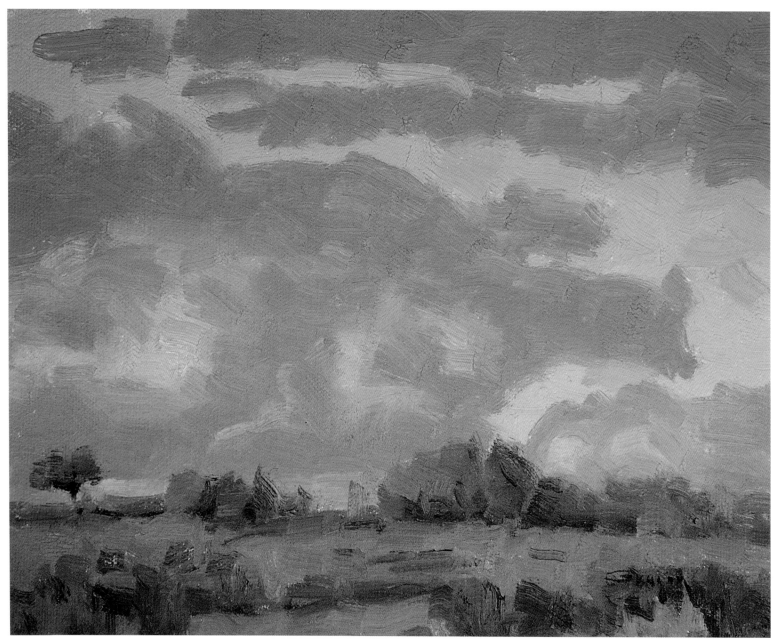

Grootkolk Skies, oil on canvas, 8" x 10"

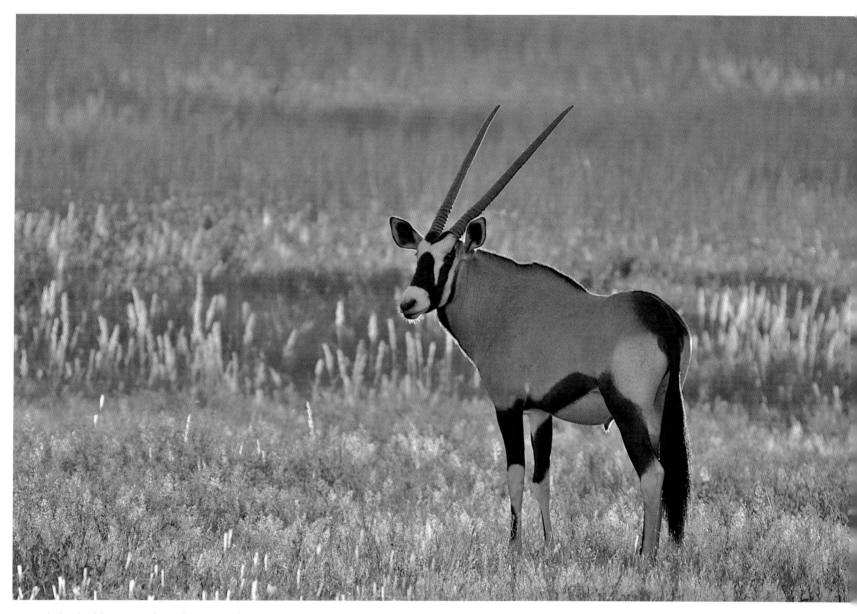

A gemsbok is backlit against the early morning light. The horns seem impossibly long relative to this antelope's body size. Unusually, it is the females who often have the longest horns.

OVERLEAF *Storm clouds silhouette a giraffe above the Auob Valley. Giraffes have disappeared from most of the Kalahari but have been successfully reintroduced into the Kgalagadi Transfrontier Park.*

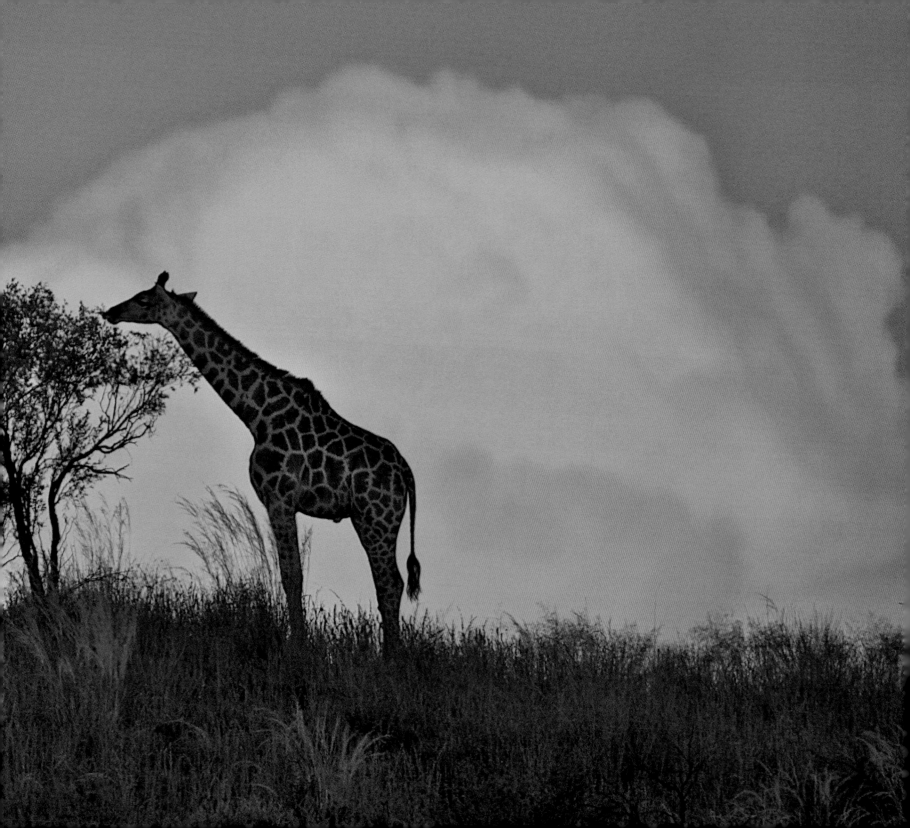

Let it rain

Flowing water is a rare sight in the Kalahari. Animals often seem to relish the event and make no attempt to shelter from the downpour. Here a springbok, blue wildebeest and ostrich enjoy a cooling shower.

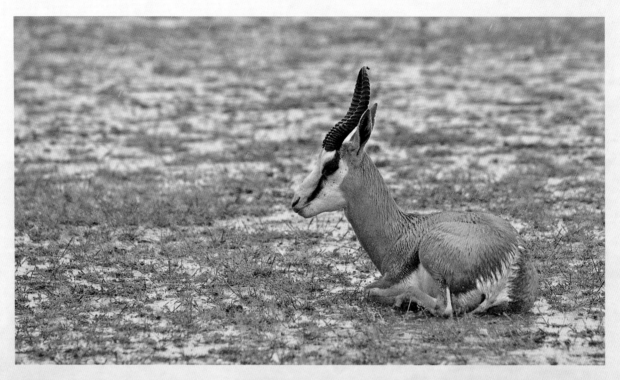

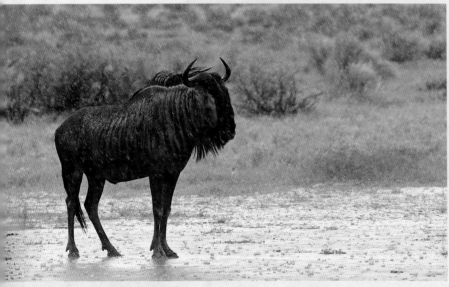

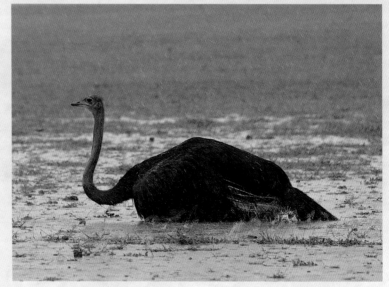

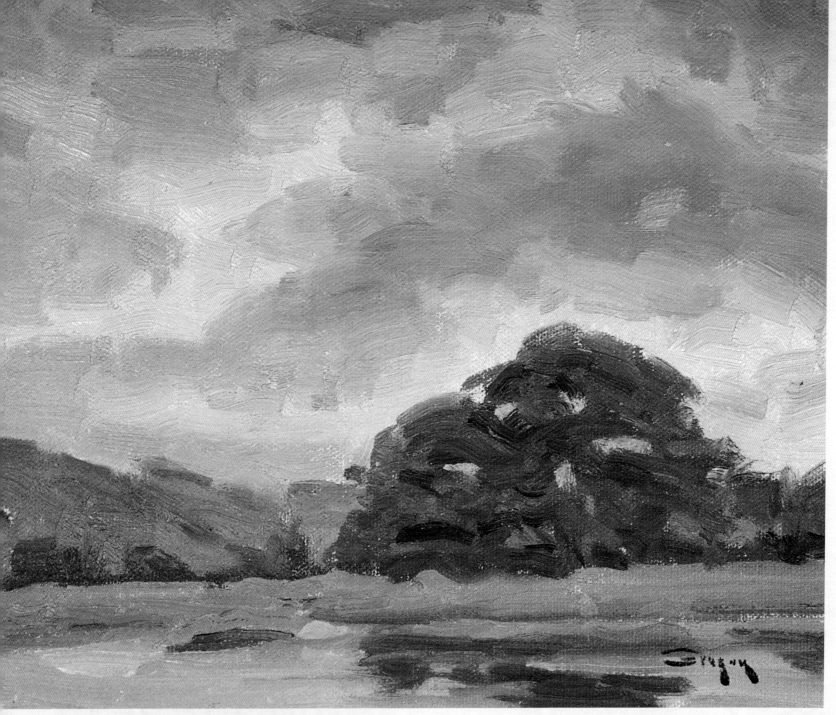

After the Rain – Samevloeiing, oil on canvas, 8" x 10"

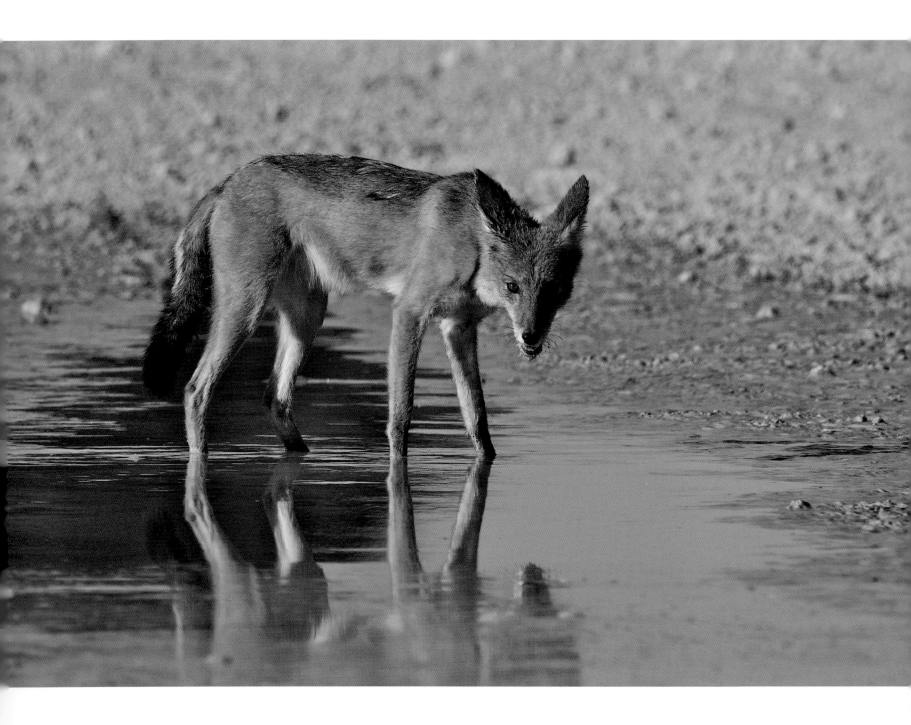

While most of the Kalahari's creatures can cope with long periods of drought, they do seem to revel in the arrival of water in summer. For example, the black-backed jackal shown opposite has waded right into a cooling pool. Birds like the southern masked weavers shown to the left and the Egyptian geese below are frequently seen bathing and drinking at water-holes in the summer season.

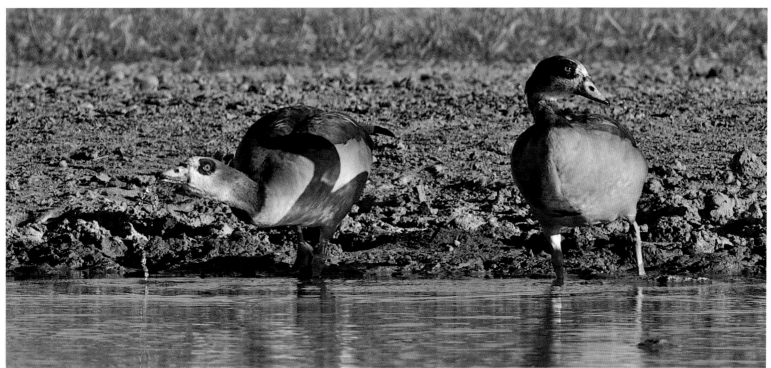

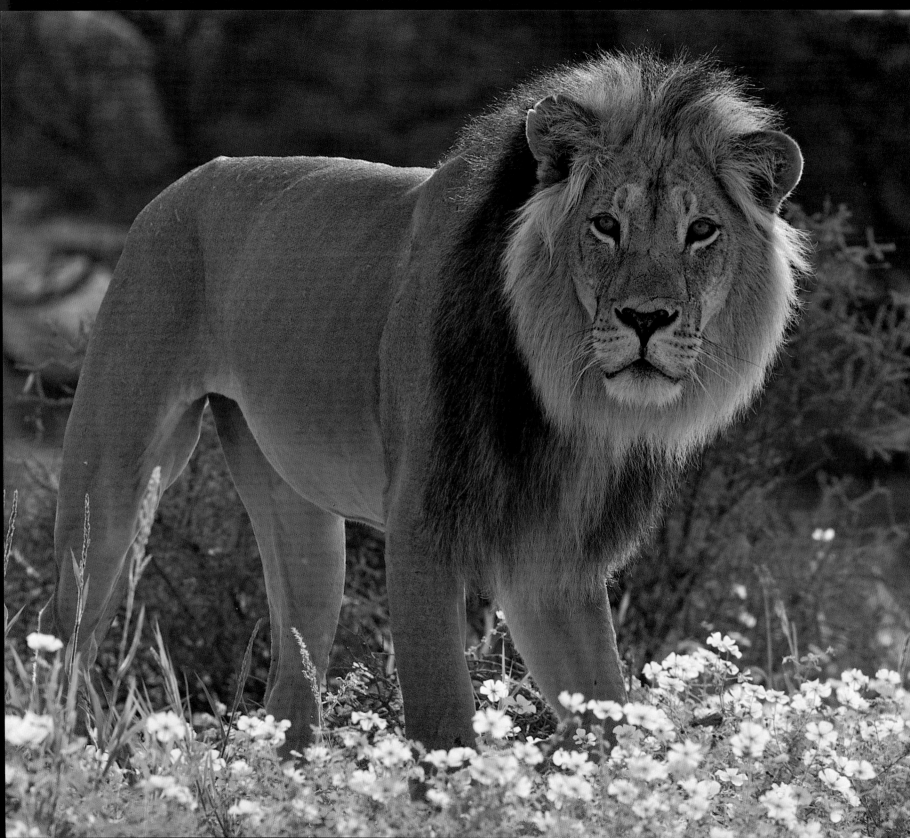

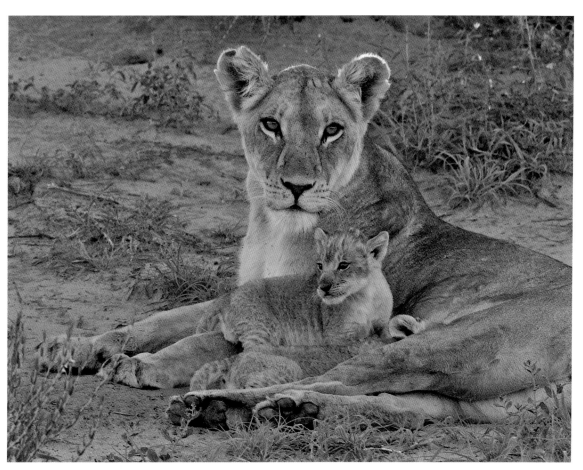

*Lion prides are widespread in the Kgalagadi
Transfrontier Park, providing plenty of
viewing and photographic opportunities.
Shown to the left is a mature male standing
in a field of flowers, while the family portrait
above shows a female and her cubs in the soft
light of evening. Female lions within a pride
sometimes raise their offspring together.*

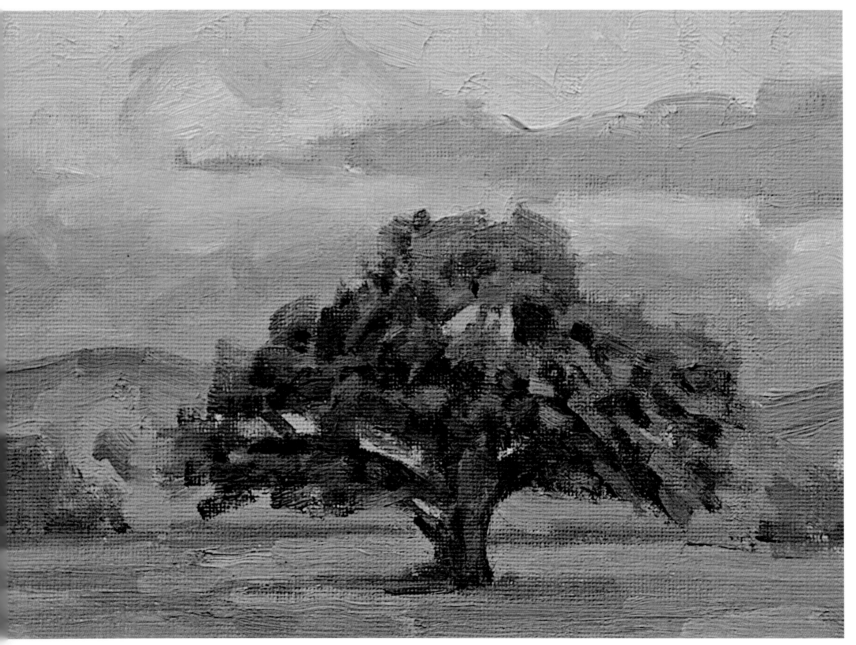

Camelthorn in Last Light, oil on canvas, 6" x 8"

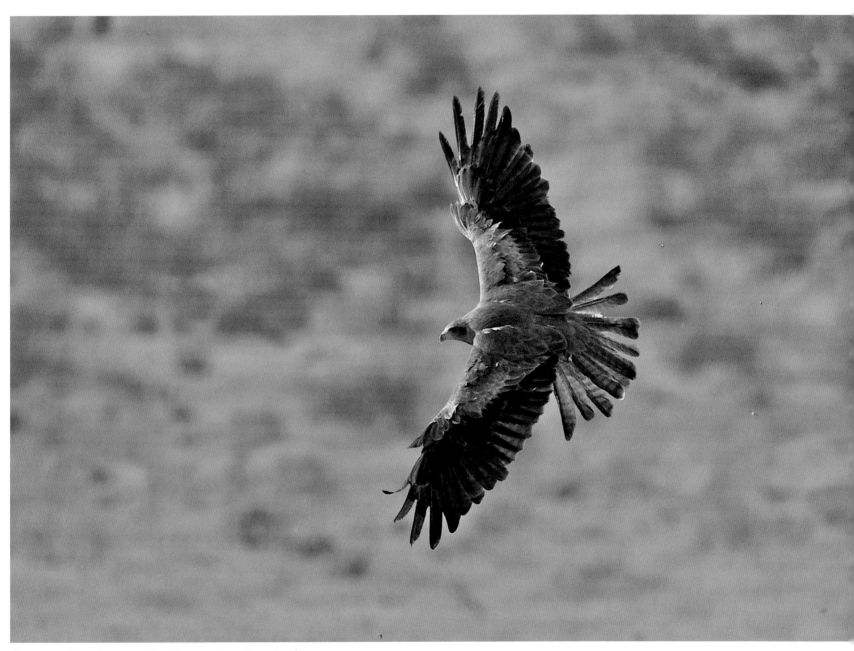

A tawny eagle makes a steep banking turn just prior to landing.

A rare encounter

In the Auob riverbed at first light one morning we spotted this springbok ram with something small moving at its feet. A quick glance through binoculars revealed an African wild cat. For the next few minutes, we watched the pair cavorting – clearly enjoying each other's company. To see these normally adversarial species interacting so playfully seemed extremely unlikely, and we watched in amazement. The arrival of a jackal in the riverbed interrupted their play, and the cat disappeared into thick bush.

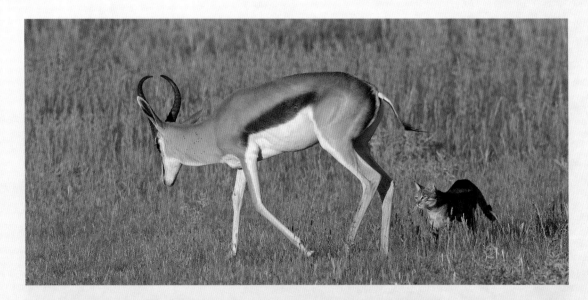

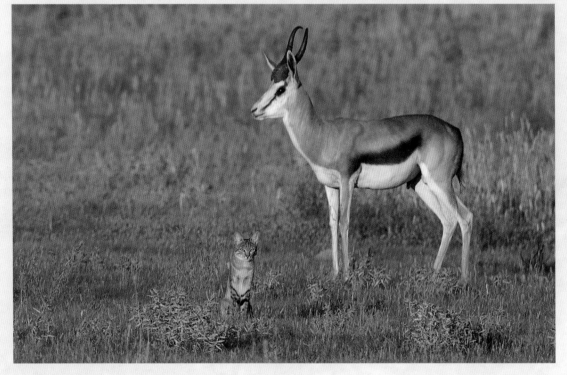

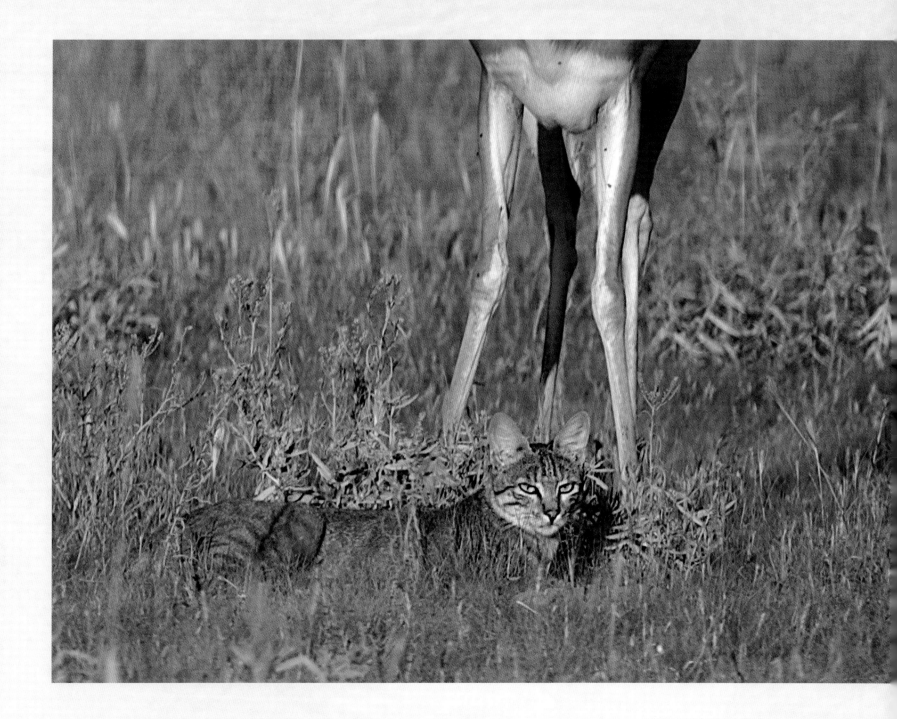

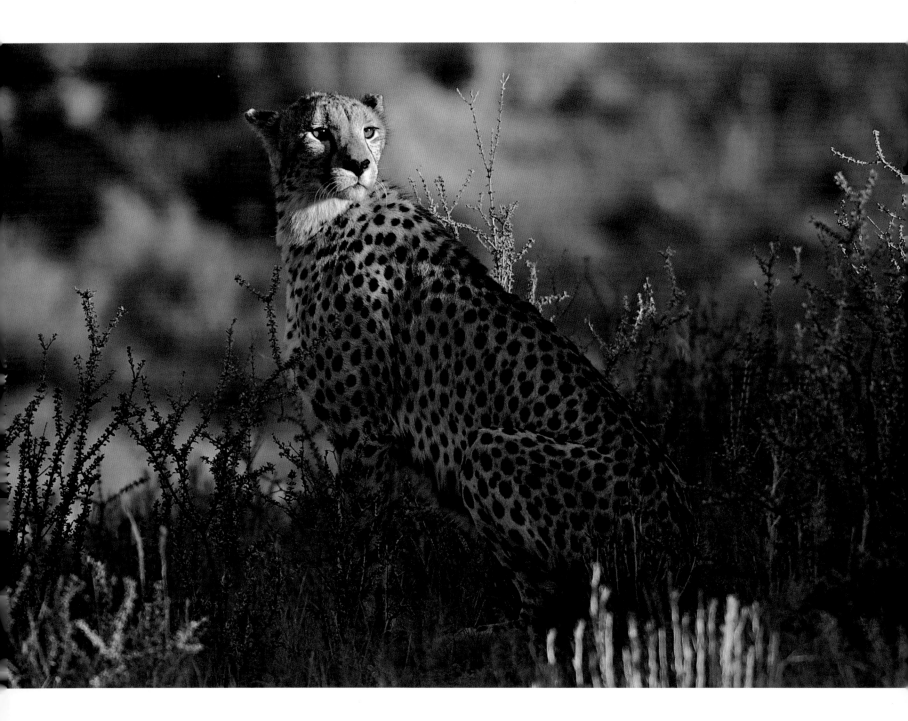

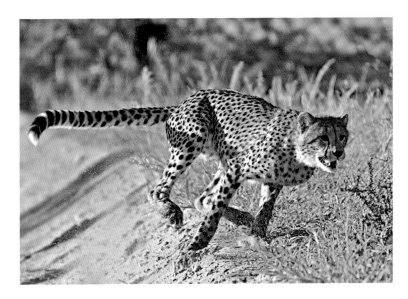

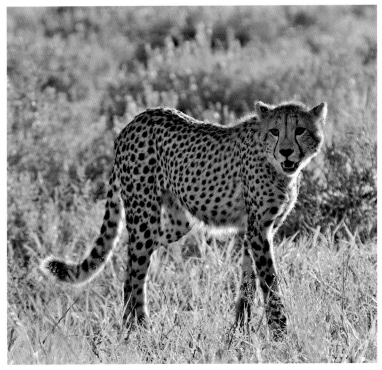

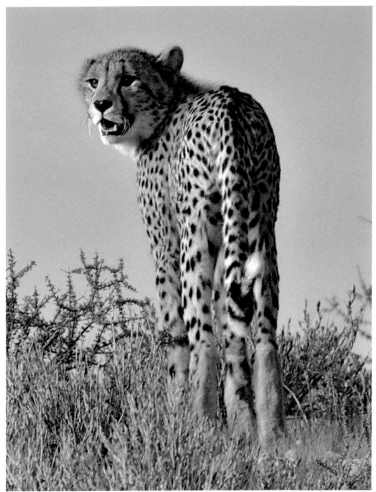

Observing cheetahs in the Kgalagadi is a lesson in patience. Often you can follow them for many kilometres as they spot prey and set up a stalk. Their lightning speed is astonishing, always coming as a surprise to both photographer and prey. We've sometimes watched the process repeated over and over for several hours – more often than not, the cheetah is unsuccessful.

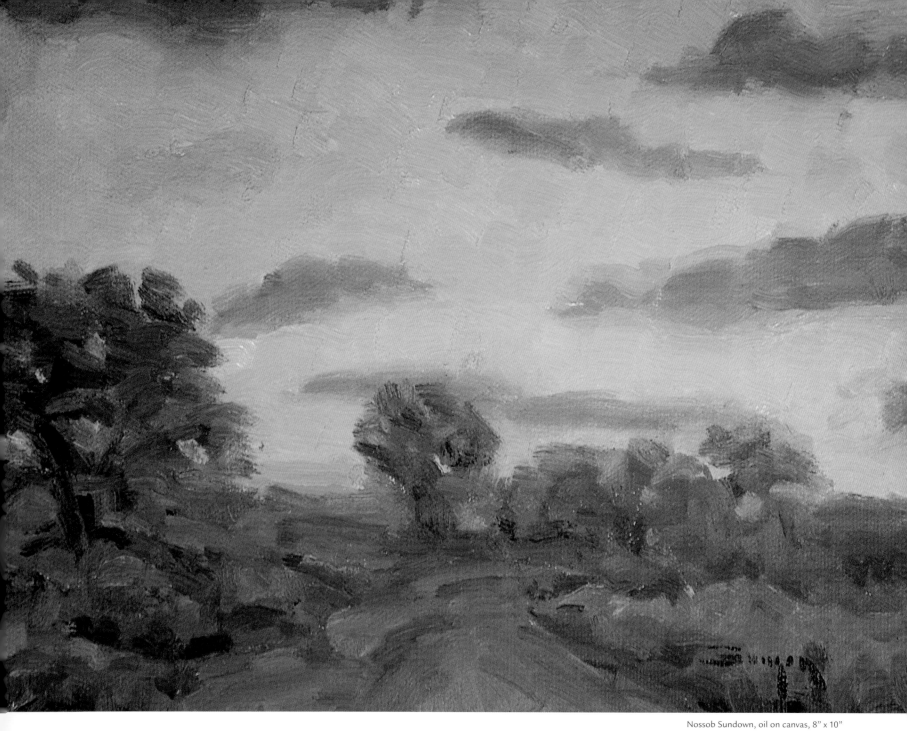

Nossob Sundown, oil on canvas, 8" x 10"

116

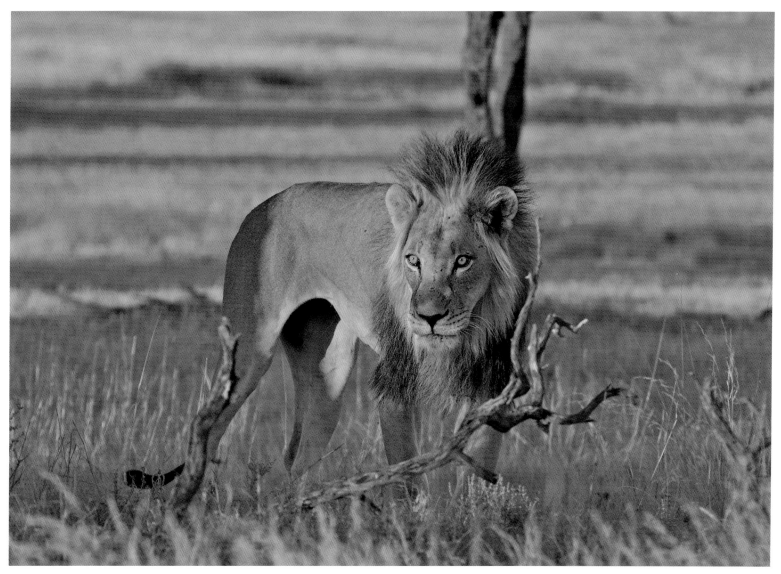

This lion is one of two males that had spent a day sleeping in the shade close to a track running along the upper Nossob. Having watched patiently for hours, and with the sun just beginning to set, I wished aloud that they would stand up so that I could get my shot. To my relief and surprise both males abruptly got up and approached at a leisurely pace, giving me the opportunity to catch the light glowing in this big cat's eyes. His dark mane is typical of mature males in the Kalahari, hence the moniker 'black-maned lions'.

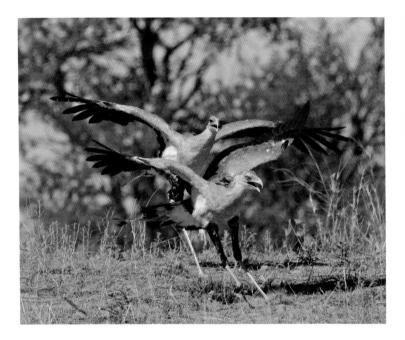

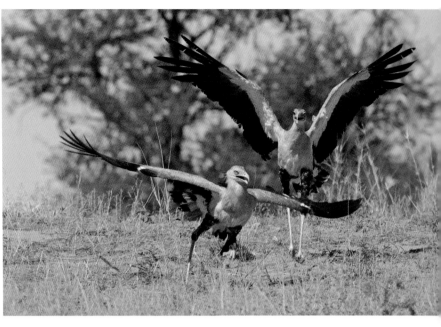

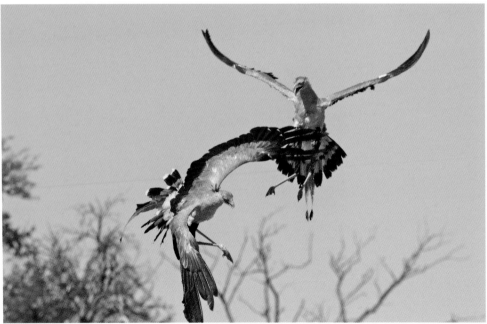

The secretarybird is fierce in defence of its territory, as evidenced by this hostile encounter. During the course of their long battle, these males covered over a kilometre on the ground. Eventually they disappeared behind a dune, leaving me to wonder about the outcome.

OPPOSITE Secretarybirds roost and build their nests in trees. They generally spend their days striding through vegetation in search of their prey, which includes snakes, various other small animals and insects.

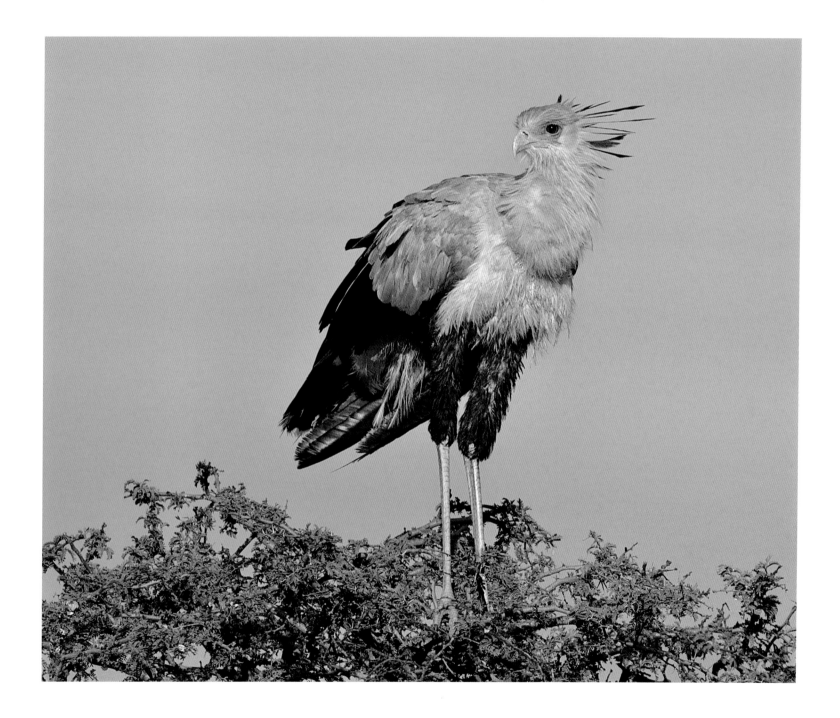

The African wild cat, the feline from which all domestic cats are descended, is difficult to spot throughout much of its African range. However, it is more readily seen in the Kalahari. The greatest threat to its survival is interbreeding with domestic cats.

OPPOSITE A male cheetah begins the day's hunt.

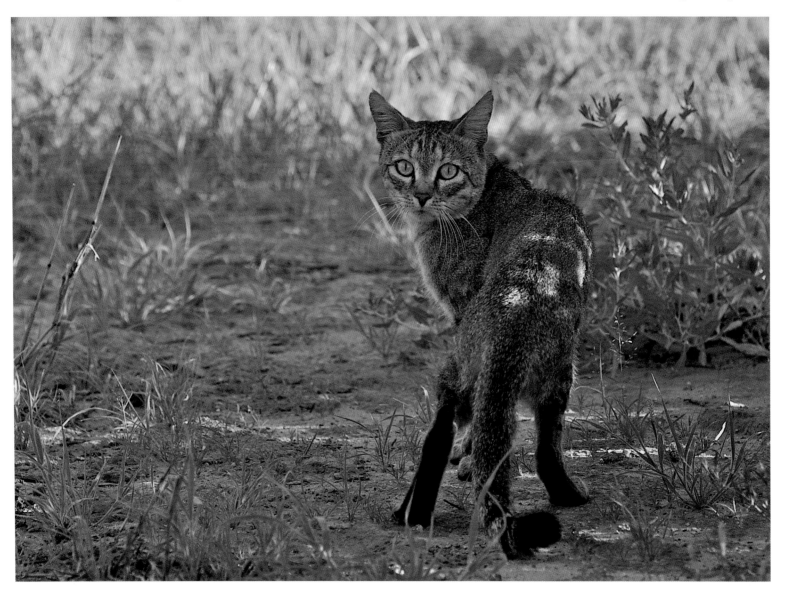

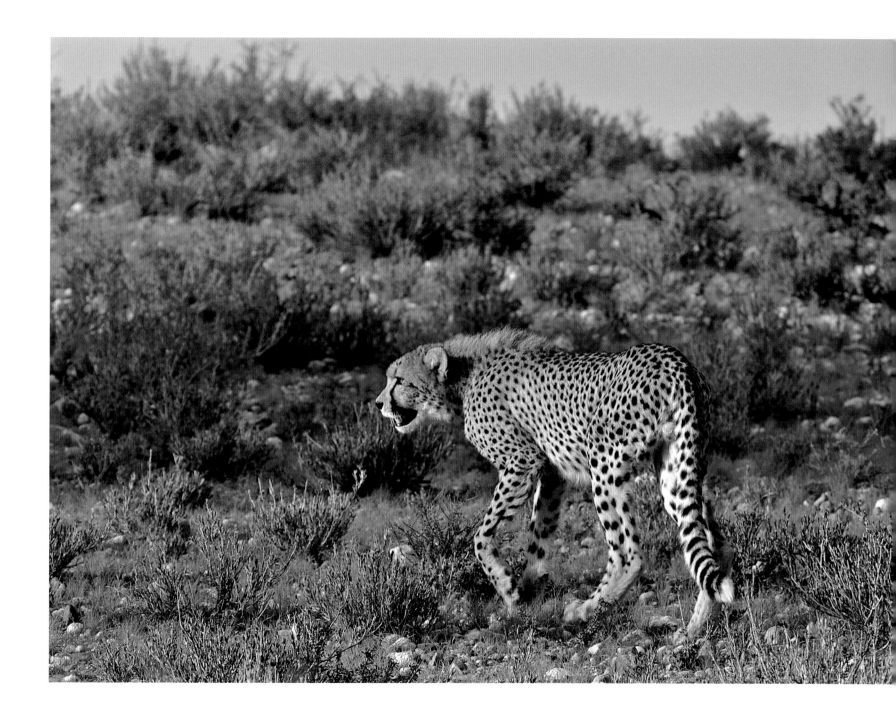

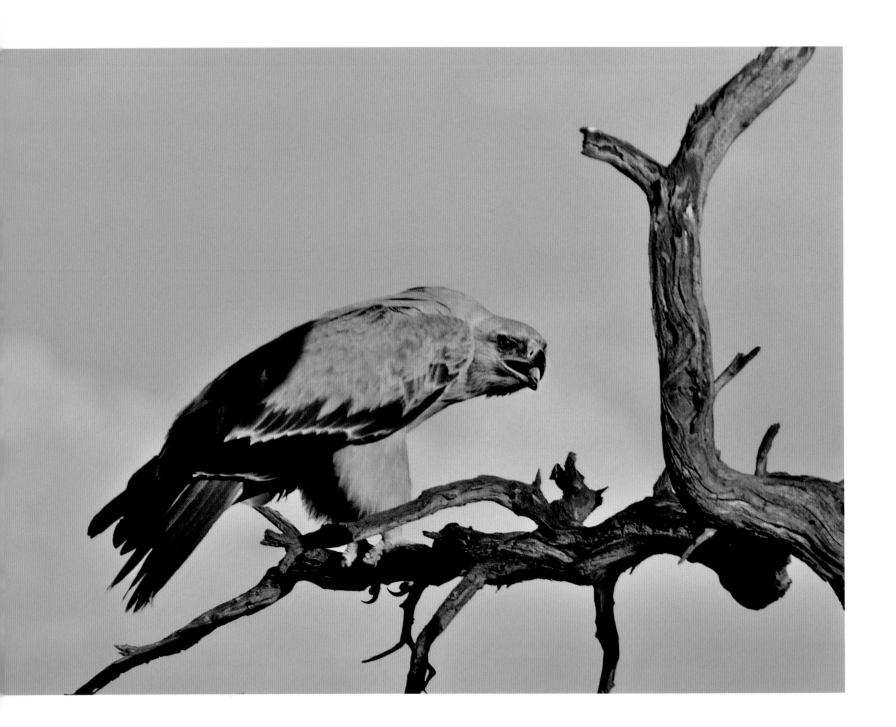

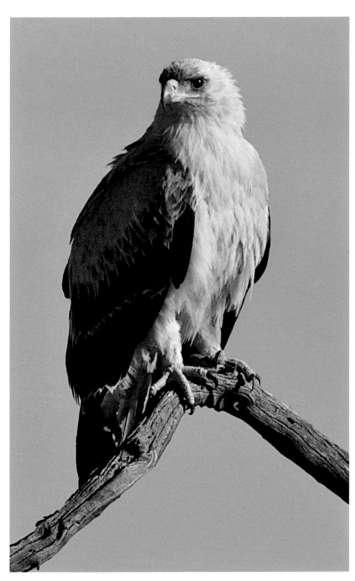

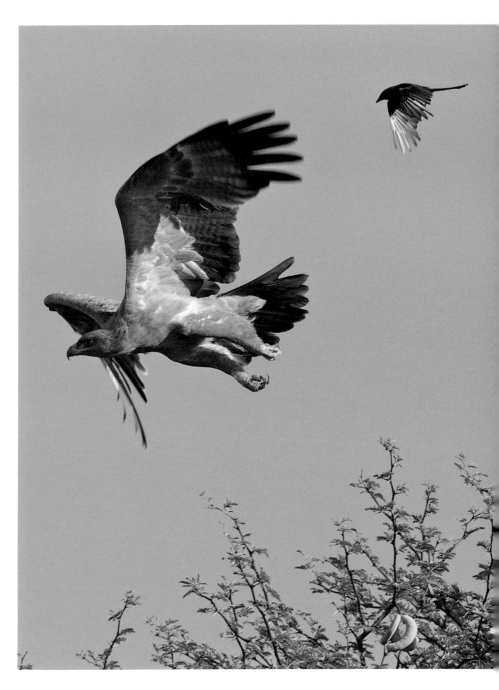

The tawny eagle, known for its shaggy feathers, is commonly seen in the Kgalagadi. These eagles prey on birds and other small animals. The image to the right shows a fork-tailed drongo harassing a tawny eagle. The drongo knew to stay above and behind the eagle so as to avoid becoming a meal.

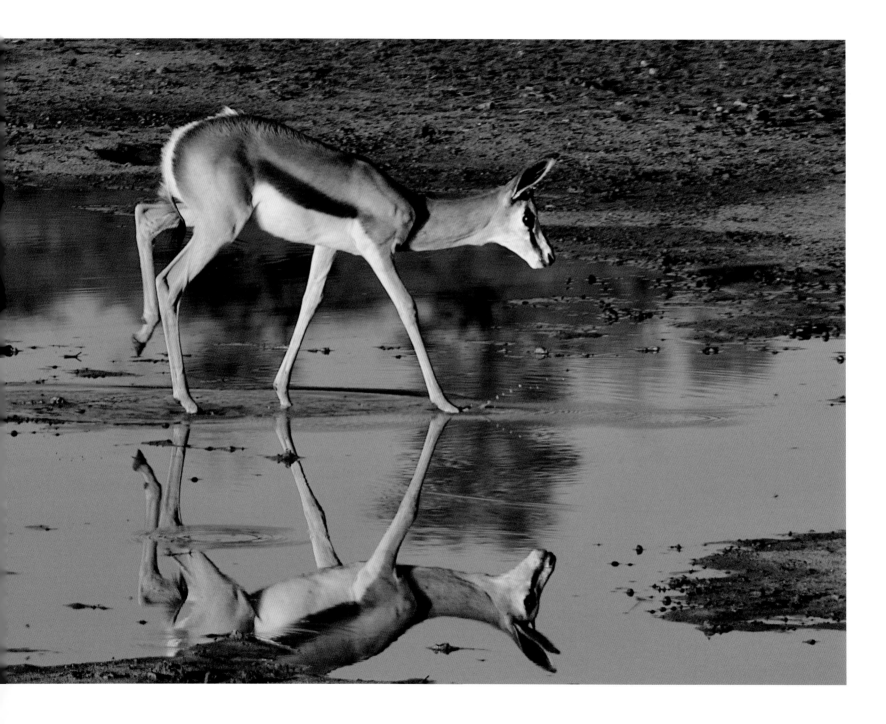

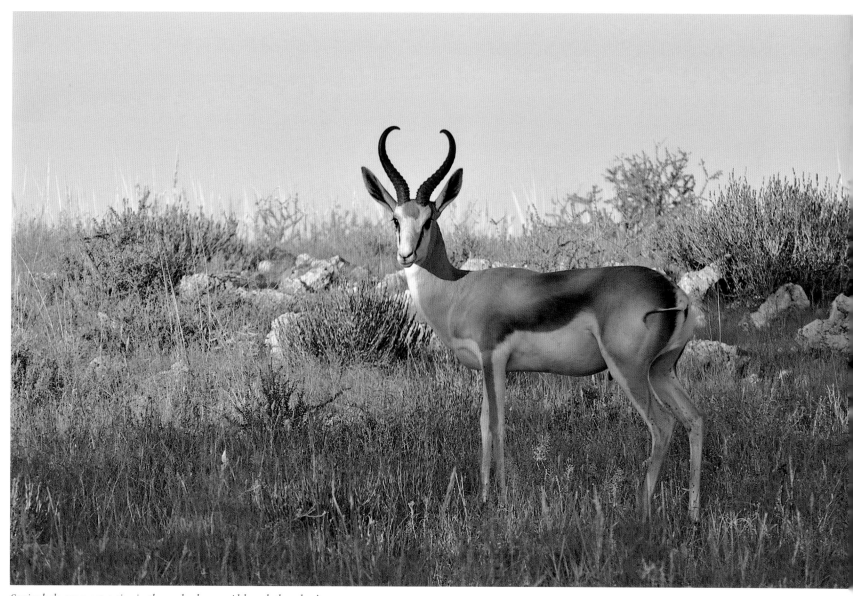

Springbok are most active in the cooler hours. Although they don't depend on it, they will drink surface water if it is available. Above is a ram, photographed in the early morning light, while opposite is a female, reflected in a standing pool.

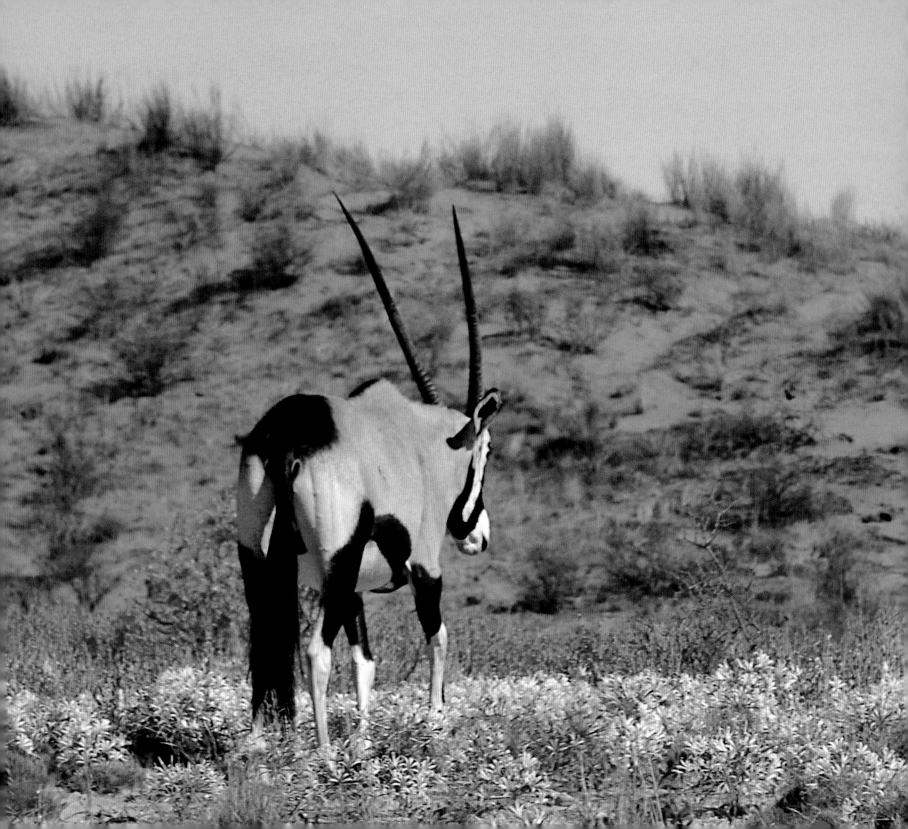

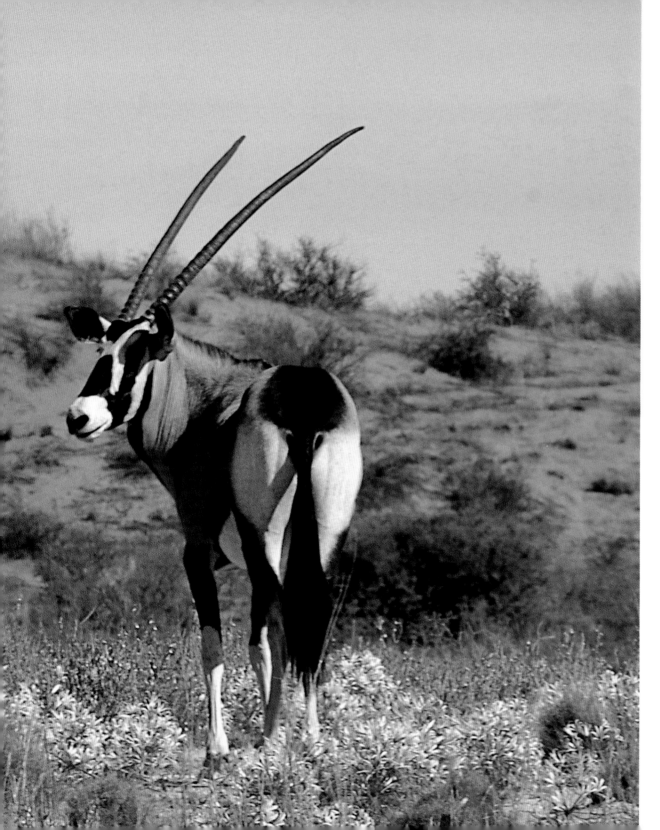

Gemsbok are arguably the most spectacular of the Kalahari's prey animals. The pair featured here are standing in a patch of vlei lilies.

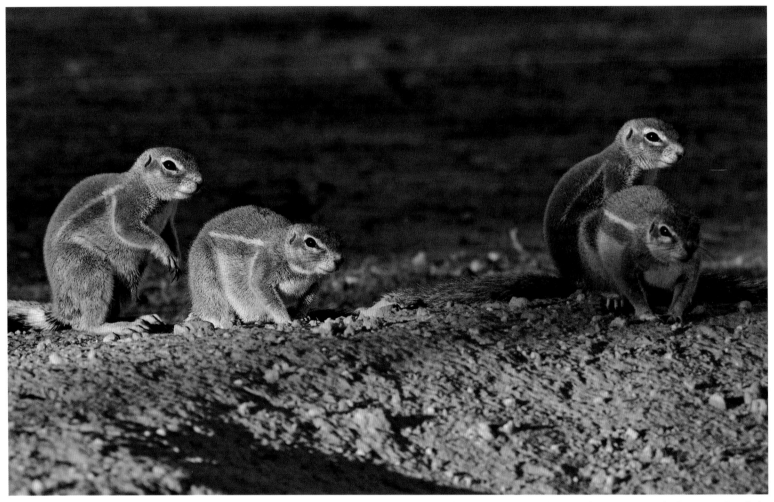

These southern African ground squirrels are enjoying the last rays of sunlight before they head down into their den. This species' burrow systems are extensive, and males live separately from females and their young.

OPPOSITE *Also enjoying a late summer's evening, this suricate (meerkat) seemed to pose for me amid the yellow blossoms. These ubiquitous small creatures may make use of squirrels' burrows, although they can dig their own. Indeed, the two species seem to get along quite harmoniously.*

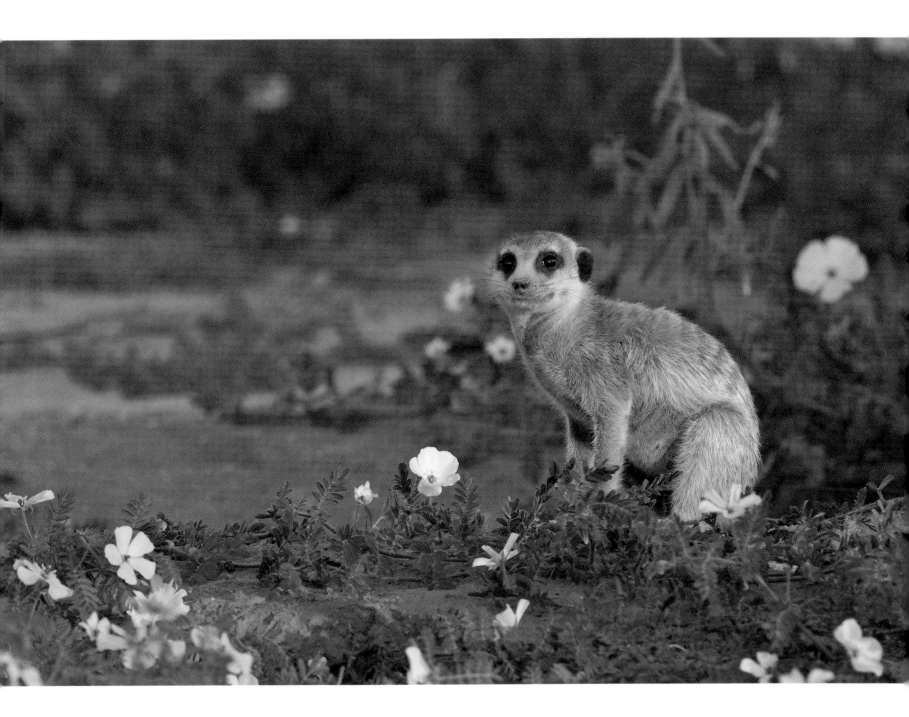

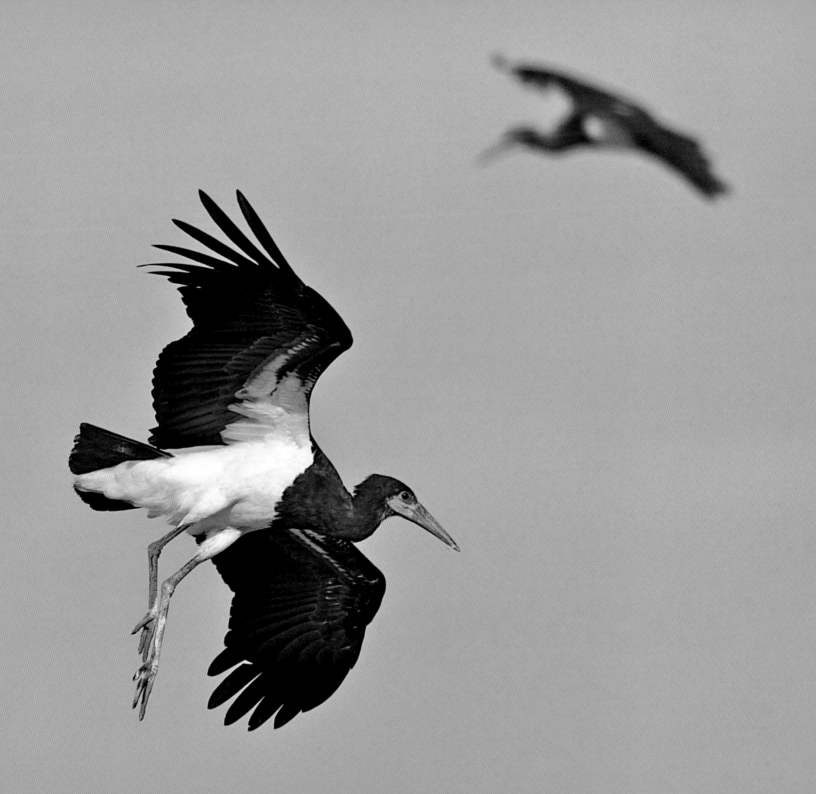

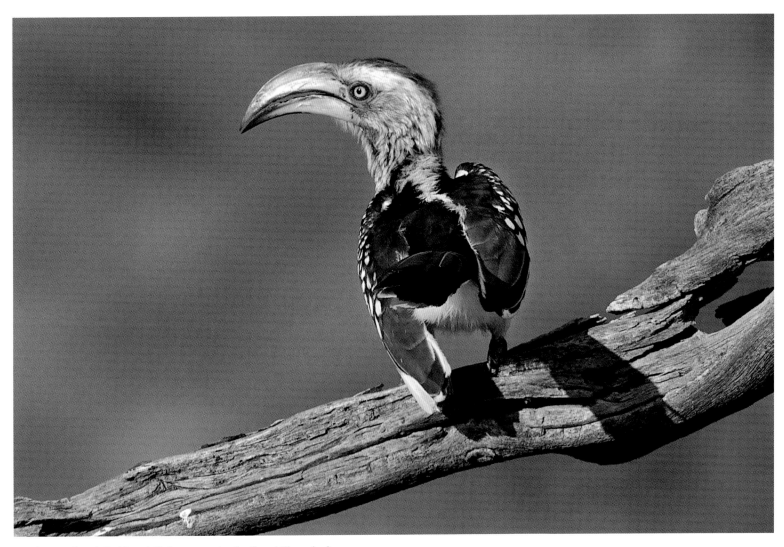

Southern yellow-billed hornbills have oversized yellow bills and other characteristic colourful markings.

OPPOSITE *Abdim's storks descend in a spiralling flight. These small storks migrate from the northern parts of Africa to enjoy the southern summer. They arrive with the rains, just in time to feast on insects. They tend to circle slowly when coming in to land, which makes them easy to photograph in flight.*

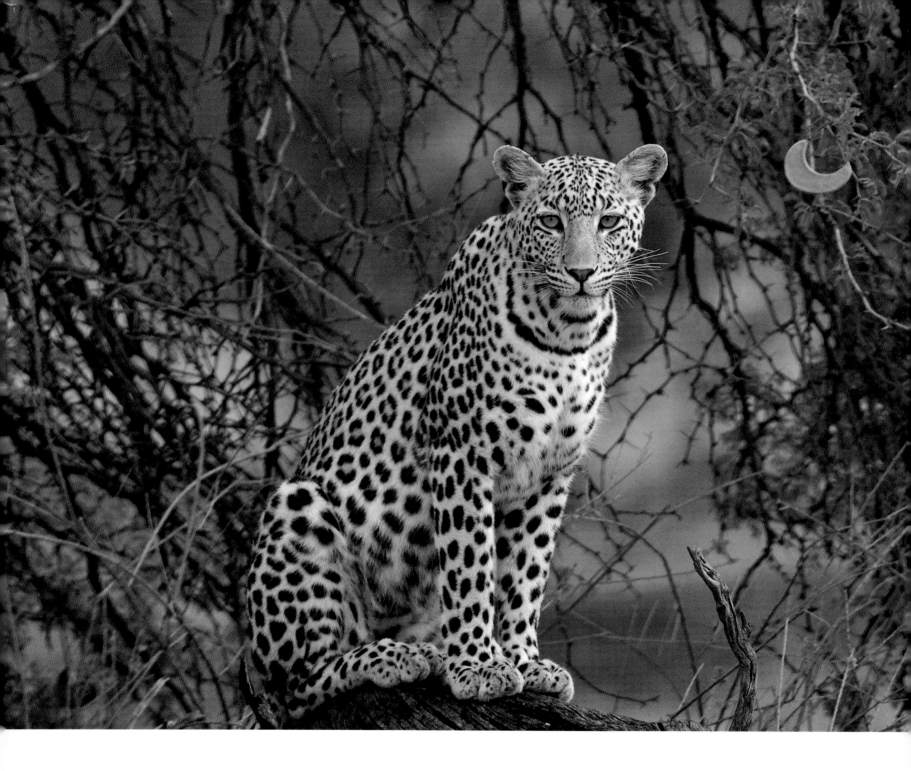

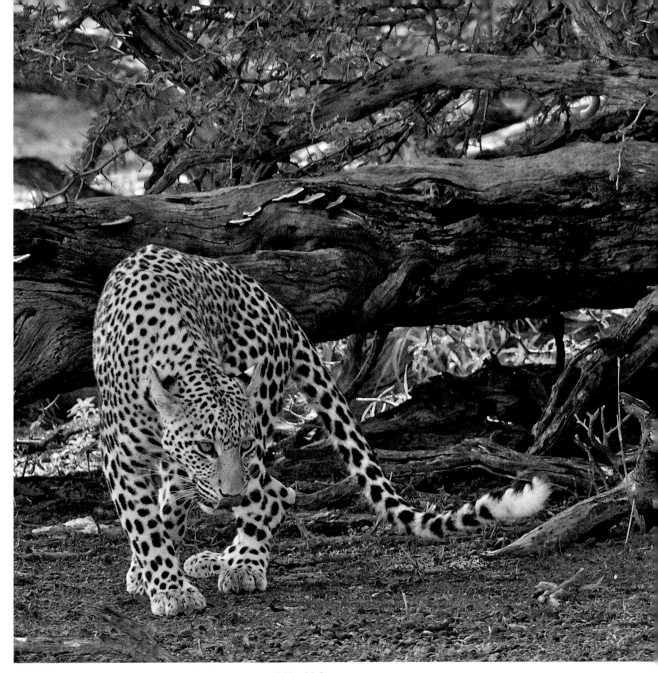

Leopards are opportunistic hunters. They have a powerful build that allows them to take down quite large prey. In the Kalahari, however, they seem to focus on smaller animals and birds and often finish a meal in one sitting, thus eliminating the need to stash the kill in a tree.

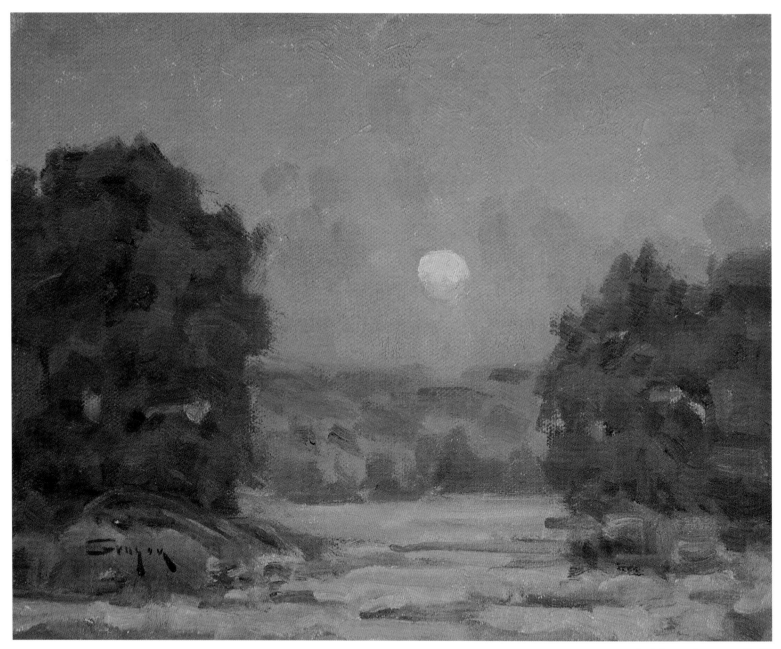

Auob Sunset, oil on canvas, 8" x 10"

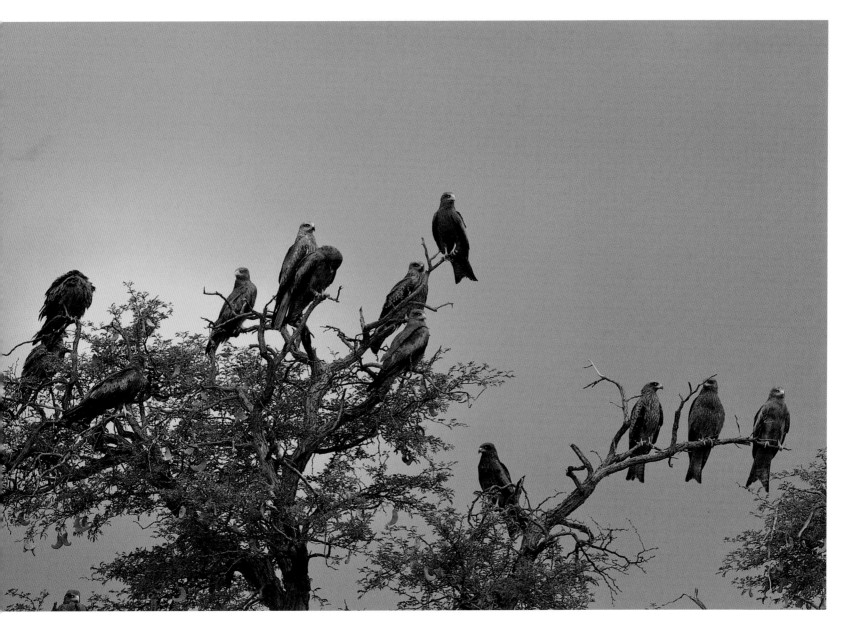

Yellow-billed kites breed in southern Africa during the summer months and congregate in massive numbers near the Nossob Rest Camp. On this occasion I was struck by how surreal, even eerie, they looked roosting in a tree against the backdrop of storm clouds at sunset.

Published by Struik Nature
(an imprint of Random House Struik (Pty) Ltd)
Reg. No. 1966/003153/07
Wembley Square, First Floor, Solan Road,
Gardens, Cape Town, 8001
PO Box 1144, Cape Town, 8000 South Africa

Visit **www.randomstruik.co.za** and join the Struik Nature Club
for updates, news, events and special offers.

First published in 2013

10 9 8 7 6 5 4 3 2 1

Publisher: Pippa Parker
Managing editor: Helen de Villiers
Editor: Emily Bowles
Designer: Janice Evans
Cartographer: James Berrangé

Reproduction by Hirt & Carter Cape (Pty) Ltd
Printed and bound by 1010 Printing International Ltd, China

ISBN 978 1 92057 292 1

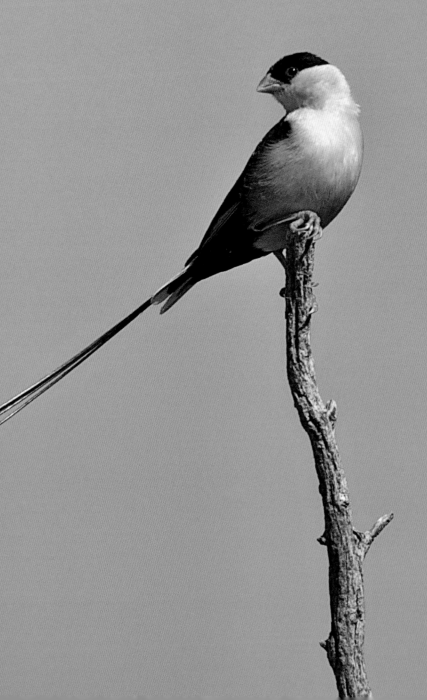

In the breeding season male shaft-tailed
whydahs display their elongated tail
feathers. They shed them after breeding.